MOBILIZING

TWO SOCIAL PRACTICE PROJECTS IN THE AMERICAS

BY PABLO HELGUERA
AND SUZANNE LACY
WITH PILAR RIAÑO-ALCALÁ

EDITED BY
ELYSE A. GONZALES AND
SARA REISMAN

PEDAGOGY:

MOBILIZING

TWO SOCIAL PRACTICE PROJECTS IN THE AMERICAS

BY PABLO HELGUERA

AND SUZANNE LACY

WITH PILAR RIAÑO-ALCALÁ

EDITED BY

ELYSE A. GONZALES AND
SARA REISMAN

PEDAGOGY:

AMHERST COLLEGE PRESS
Robert Frost Library • Amherst, Massachusetts • acpress.amherst.edu

The complete manuscript of this work was subjected to a partly closed
("single-blind") review process. For more information, see
https://acpress.amherst.edu/peer-review-commitments/

The editors acknowledge with gratitude the support of the Shelley and
Donald Rubin Foundation and the Art, Design & Architecture Museum of
the University of California, Santa Barbara.

Creative Direction & Graphic Design by Oliver Dickson.

ISBN 978-1-943208-12-8 paperback
ISBN 978-1-943208-13-5 electronic book

Library of Congress Control Number: 2018950898

CONTENTS

INTRODUCTION 04
 by Elyse A. Gonzales and Sara Reisman
THE SCHOOLHOUSE AND THE BUS 06
 by Elyse A. Gonzales
THE SCHOOL OF PANAMERICAN UNREST 16
 Project Description by Holly Gore
DOCUMENTATION: *THE SCHOOL OF PANAMERICAN* 18
UNREST (2006)
JOURNEY NOTES OF PANAMERICA: 25
THE SOCIAL PRACTICES OF ART
 A conversation between artist Pablo Helguera
 and Adetty Pérez de Miles
DOCUMENTATION: *THE SCHOOL OF PANAMERICAN* 34
UNREST (2006) CONTINUED
OBJECT LESSONS: THE ROLE OF MATERIAL 42
CULTURE IN SOCIALLY ENGAGED ART
 by Sara Reisman
SKIN OF MEMORY 48
 Project Description by Holly Gore
DOCUMENTATION: *SKIN OF MEMORY* (1999) 50
DOCUMENTATION: *SKIN OF MEMORY* (2011) 62
RELATIONSHIPS, MATERIALITY, AND POLITICS IN THE 68
SKIN OF MEMORY
 A conversation between Suzanne Lacy
 and anthropologist Pilar Riaño-Alcalá
PEDAGOGICAL PUBLICS 74
 by Shannon Jackson
DOCUMENTATION: *THE SCHOOLHOUSE AND THE BUS*, 78
AD&A MUSEUM (2017)
ON SOCIAL PRACTICE 82
 A conversation between Suzanne Lacy
 and Pablo Helguera
DOCUMENTATION: *THE SCHOOLHOUSE AND THE BUS*, 88
THE 8TH FLOOR (2018)
BIOGRAPHIES 91
ACKNOWLEDGMENTS 94
MAP 96

INTRODUCTION
ELYSE A. GONZALES AND SARA REISMAN

Mobilizing Pedagogy: Two Social Practice Projects in the Americas by Pablo Helguera and Suzanne Lacy with Pilar Riaño-Alcalá is the result of conversations about the nature of art's role in society. Related to this publication is an exhibition, *The Schoolhouse and the Bus: Mobility, Pedagogy and Engagement,* which highlighted two projects by the artists that serve as the basis for this book. Though our audiences and settings are incredibly different—with one at a university in Santa Barbara, a regional seaside city, and the other in New York City, a major urban art center—both of our institutions are focused on the belief that art and artists can transform individuals and communities. These transformations may not always be immediately visible, but we regard artists as having the potential to be catalysts for change, especially through dialogue that fosters mutual understanding. Our audiences, with their vantage points from the east and west coasts, largely comprised of students, faculty, activists, practicing artists, and other cultural producers, are eager to understand the means and methods of utilizing art to affect change in these particularly unstable and challenging times.

Focusing on the work of two social practice artists was a natural outgrowth of our conversations, considering the field's emphasis on engagement, with a goal of affecting positive outcomes in relation to social and political concerns. The more we talked and listened, the more we understood the book and exhibition as an opportunity for broader audiences to experience the work of important artists in this genre. Suzanne Lacy and Pablo Helguera represent two generations of socially engaged artists who have also built their careers and work on pedagogical engagement. Their transcribed exchange "On Social Practice: A conversation between Suzanne Lacy and Pablo Helguera," serves as a terrific record of the artists' overlapping concerns and guiding principles.

The works we have chosen to highlight are seminal for not only Helguera and Lacy as artists, but also the field itself. Helguera's *The School of Panamerican Unrest* (2006) and Suzanne Lacy/Pilar Riaño-Alcalá's *Skin of Memory* (1999–2017) are focused on local conditions, from the broad perspective of twenty-nine communities in the Americas to a single neighborhood in Medellín, Colombia, respectively. Additionally, linked by their mutual emphasis on mobility, both artists are attendant to the ways in which geographic location informs the possibilities of social and political transformation—a concept addressed in essays by Elyse A. Gonzales and by Shannon Jackson, UC Berkeley professor and a leading thinker in social practice. Another incentive in organizing this exhibition and publication was the opportunity to delve into questions and concerns that revolve around exhibiting social practice works, which are made for a specific time and place. Sara Reisman's essay unpacks the complex nature of representing these live, audience-based works through the objects that remain and the projects' more ephemeral, lasting impacts.

05

We see *Mobilizing Pedagogy* not only as an essential record of these artists' projects and contributions to the field, but also as a lens through which readers can examine the issues raised therein. Just as importantly, we see the relational and experiential nature of these works as a means of highlighting the essential aspects of social practice, an art form that is increasingly bridging the divide between art and activism.

THE SCHOOLHOUSE AND THE BUS
BY ELYSE A. GONZALES

1 Suzanne Lacy, ed., *Mapping the Terrain: New Genre Public Art* (Seattle: Bay Press, 1995).
2 Pablo Helguera, *Education for Socially Engaged Art: A Materials and Techniques Handbook* (New York: Jorge Pinto Books Inc., 2011).

Suzanne Lacy and Pablo Helguera are social practice artists, representing two generations, who have helped shape the field through their influential writings, teaching, and artworks. Over the past two decades, many contemporary artists have increasingly sought a way for art to foment larger societal change. This has given rise to social practice—also known as socially engaged—art, which is notable for its emphasis on performance, activism, and often non-object-centered art making. This field is reliant on audience participation generated through time-based events such as performances, conversations, and workshops. Lacy's and Helguera's works are further identifiable as socially engaged art by the fact that they respond to cultural and political concerns, promoting the empowerment and transformation of communities. In short, they intend for their work to be catalysts of positive change for the communities in which they work. Their pairing in this exhibition is based on a number of connections and intersections between their respective practices.

Lacy and Helguera have taught together, conducted public conversations with each other, and even collaborated on a work at the College Art Association's annual conference in Los Angeles (2012), staged as an impromptu class about social practice. Despite this history, their contributions to the field have never been specifically addressed in relation to each other. Their deep affinities include the means and methods by which they have influenced socially engaged art, not only through their works but also through their extensive and ongoing writings and teachings about the field, all of which continue to contribute to the implementation and interpretation of socially engaged art.

Lacy (b. 1945, Wasco, CA) is a pioneering social practice artist, and her work dates to the early 1970s, through her initial involvement in the feminist art movements. Highly influential, her unique artistic vision is related to social issues such as class, mass media, violence, and racial and gender inequities. Many of her earlier artworks serve as primary exemplars of what was then called "new genre public art," a term Lacy coined in her influential writings, which preceded "social practice." *Mapping the Terrain: New Genre Public Art* (1995), the most well known of her books, was the first definitive collection of essays devoted to explaining the field with her own selections, as well as those by other artists and curators.[1]

Helguera (b. 1971, Mexico City) represents the next generation of social practice, and his work has evolved using methods of public engagement that are in dialogue with Lacy's seminal strategies. For the last twenty years he has made work that addresses a range of subjects including anthropology, museums, pedagogy, sociolinguistics, ethnography, memory, and the absurd. Helguera, like Lacy, has contributed extensively to the discourse of social practice: in addition to publishing numerous articles on the subject of social practice, his book *Education for Socially Engaged Art: A Materials and Techniques Handbook* (2011) became an influential text within the field.[2] While Lacy's book established and laid out the nascent territory of social practice, *Education for Socially Engaged Art* is the first social practice primer to offer practical advice for making socially engaged art that is both artistically and ethically sound. Furthermore, the book raises issues and questions related to assessment of socially engaged art, advocating the use of tools from other fields of study as a potential means of addressing this concern. This is an increasingly important discussion topic that Helguera has spearheaded, considering social practice's growing popularity, and the fact that this genre, by its very nature, eschews traditional notions of success—that is, the expected formal and aesthetic parameters established by the mainstream art world.

These artists also share a keen understanding of pedagogy and an incorporation of pedagogical principles into their work, which is to be expected considering social practice's roots in learning and teaching techniques. From early on, Lacy has incorporated fundamental pedagogical tools into her practice, of which the most essential are conversation and the act of listening. As she often states, these two basic tools guide her throughout the research, development, and implementation phases of her projects, with the hope of changing cultural attitudes by informing and engaging diverse audiences.

07

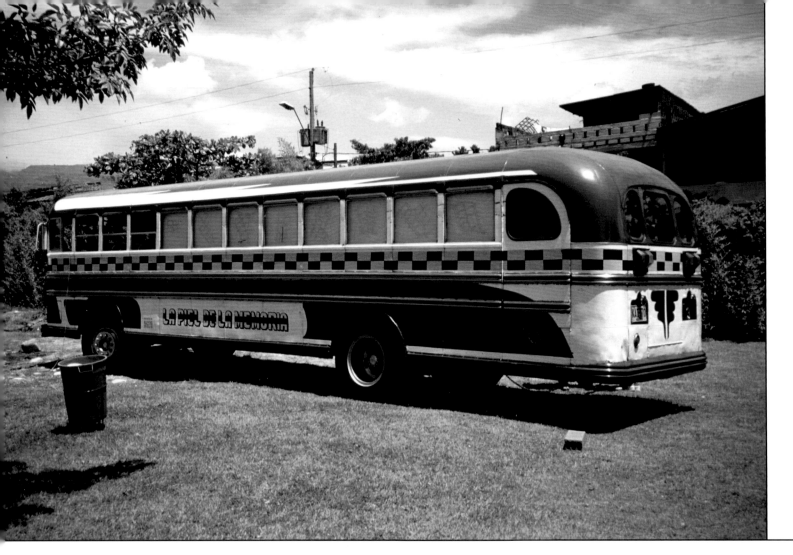

Helguera is perhaps best known for works that are overtly about and based on principles of pedagogy, works that collectively incorporate standard learning elements such as lectures, symposia, workshops, and games. *Education for Socially Engaged Art* articulates his investment in pedagogy, arguing that educational tools are not only useful but also essential for producing socially engaged art.[3] Although Helguera was already invested in this methodology, he credits Lacy—a reader of the book's early drafts—with helping him to realize that pedagogy should be more of a focal point.[4]

The incorporation of pedagogy and pedagogical methods is less surprising when one considers that both artists have taught social practice. For over thirty years Lacy has influenced the study of social practice at the university level, by helping to establish academic programs devoted to socially engaged art, most recently in 2002 as Founding Chair of the MFA program in Public Practice at Otis College of Art and Design. In 2016, she was named a professor of art at USC's Roski School of Art and Design, where she continues to influence and train scores of artists in the field. Simultaneous to his practice, Helguera works as a museum educator—currently as Director of Adult and Academic Programs at the Museum of Modern Art in New York. Like Lacy, Helguera has helped the public, artists, and students learn about and understand how to produce socially engaged works through his own museum education programs, as well as numerous international adjunct teaching positions. (For more in-depth information about both these artists please see their artist biographies on pages 91–92.)

Rather than conduct a broad survey in the form of a book or exhibition —an impossibility considering their equally extensive bodies of work, and the expansiveness of their working methods— *Mobilizing Pedagogy* focuses on one significant project by each of these artists, demonstrating their affinities and reflecting a conversation about art and the artists through the development of social practice.

Lacy's *Skin of Memory* (1999–2017), executed with Pilar Riaño-Alcalá, and Helguera's *The School of Panamerican Unrest* (2006) are artistically and personally pivotal projects linked by their emphasis on public engagement, pedagogy, and mobility. These critical elements continue to make these works seminal for the field. (An in-depth description of both of the projects can be found on pages 17 and 49.)

SKIN OF MEMORY: A MOBILE MUSEUM FOR THE COMMUNITY

Skin of Memory was initially presented in Medellín, Colombia, in collaboration with cultural anthropologist and professor Pilar Riaño-Alcalá of the University of British Columbia, Vancouver. Lacy was invited by Riaño-Alcalá, who is from Colombia and has worked for many years in Medellín, to develop an art project in relation to an ongoing, multiplatform initiative that dealt with the incessant social disruption of Barrio Antioquia, a neighborhood routinely affected by drug-related and political violence. Guided by Riaño-Alcalá's in-depth (and continuous) research on youth, violence, and memory in Medellín, the two collaborated with numerous stakeholders, including community members, activists, educators, artists, architects, historians, social scientists, and NGOs. Together, they developed a project that transformed a bus into a mobile museum. Locals lent over 500 mementos that filled the interior and relate to their lived experience of this violent neighborhood, whether joyful or mournful. Many of the items on display directly relate to the rampant gang violence and deep-seated factional divides in the barrio, which made this project potentially dangerous when considering the sadness and retaliatory desires it might inspire in visitors. By treating all the objects as equally important, in a sanctified manner, on custom-made shelves outfitted with small light bulbs, the lenders and their implicit stories were given dignity and respect. Such an installation offered the residents a communal opportunity to both celebrate their neighborhood and grieve for those losses.

Pablo Helguera, phone conversation with Suzanne Lacy, July 23, 2017.
Helguera, phone conversation with Lacy.

3
4

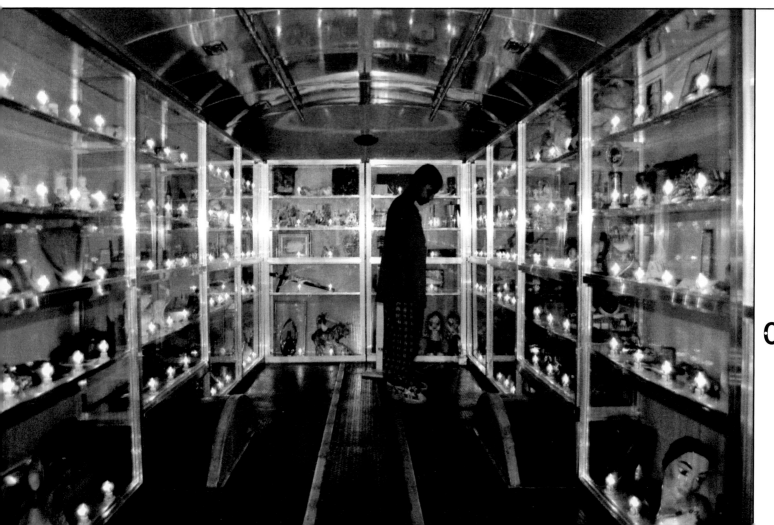

5 Suzanne Lacy and Pilar Riaño-Alcalá, "Medellin, Colombia: Reinhabiting Memory," *Art Journal* 65, no. 4 (December 2006): 105.

6 Additional discussion of this project and its impact on the community is found in numerous presentations Dr. Gutiérrez Castañeda has given, as well as his doctoral thesis dissertation, "Ejercicios del Cuidad. A propósito de La Piel de la Memoria," Escuela Nacional de Estudios Superiores, Campus Morelia, Universidad Nacional Autónoma de México, October 2016.

7 Dr. David Gutiérrez Castañeda, phone conversation with author, September 3, 2017.

8 Bill Kelley Jr., phone conversation with author, August 21, 2017.

Consequently, public emotional reactions and responses among visitors to the bus, which ran the gamut, were encouraged despite the fear of violence. Having their personal losses so publicly recognized, residents could, just as importantly, recognize the mutual suffering and losses of others.[5] Scholar David Gutiérrez Castañeda, who has written extensively on the project, sees the work as an example of how collaboration between artists, community organizers, social workers, and human rights activists can "interconnect art with social projects, with community healing.[6] In this instance, if it weren't for the art objects and their display some of the most important aspects of the grieving process in Barrio Antioquia in 1999 would not have been able to be articulated."[7] Visitors to the bus and lenders of objects were further linked by anonymous letters, in which the artists asked participants to write their hopes for the barrio's future. Such acknowledgment of collective memories and mutual hopes for the future is the fundamental basis for confronting past violence and the resulting social fragmentation, as well as the beginning of the facilitation of any kind of resolution of the traumatic past.

Skin of Memory continues to be significant for its efficacy not only as a community-building and healing exercise, but also as a seminal example of community-activist public art in Latin America, influencing a generation of youths, activists, and artists, especially in Medellín. When curator Bill Kelley Jr. was commissioned to co-curate the Encuentro Internacional de Medellín (MDE11) at the Museo de Antioquia, he asked Lacy and Riaño-Alcalá to re-present this work. In his research, Kelley came to understand that Skin of Memory was a key reference point for many who experienced or participated in the 1999 iteration. For the first time, affiliated activists and organizers saw that their work was "marked as an important cultural, artistic venture, not solely as activism. It allowed a generation of activists to consider their work in concert with, and as art, inspiring them to continue in this vein."[8]

Lacy speaks fondly of the project because it was the first time she was commissioned to make work as part of a larger initiative comprised of anthropologists, educators, community leaders, historians, social leaders, and activists. Adding to this unique opportunity was the fact that each of these team members already believed that art could be a force and means of dealing with the past in order to envision new, better presents and futures. In this instance, Lacy was able to act more like a consultant, focusing her attention on the aesthetic conceptualization of the project. As a result, she was able to execute it more quickly because there was an infrastructure for implementation, made possible through the concerted efforts of this larger overall team, already in place for several years. Unlike her previous projects (and those since), Lacy did not have to spend time making connections between stakeholders, gaining their trust, justifying the project, or organizing the production elements such as the media components and educational training. Consequently, Skin of Memory provided her with a vivid example of how artists could strategically be included as a force in the ongoing community-building initiatives of a city. However, this was only possible if a committed group of advocates valued artistic contributions and continued to maintain complex and dynamic community relations as well as the infrastructure to facilitate such projects. [9]

Foundational elements of Skin of Memory, beyond engagement, also included pedagogy and mobility. Like all her other works, this project was and continues to be built on models of learning, which promote discussion at their root. Lacy saw this endeavor as a form of public pedagogy, especially with regards to the youth and women who participated by soliciting objects from community members in Barrio Antioquia. By giving them this charge, along with appropriate training and monetary compensation, they gained important skills and, just as importantly, a sense of confidence and membership in another community of peers. "They were learning leadership skills, going to the neighborhood watch groups to speak and seeing their issues emerge as important sources for policy development."[10] As a

9 Lacy and Riaño-Alcalá, "Medellín, Colombia: Reinhabiting Memory," 110.
10 Lacy and Riaño-Alcalá, "Medellín, Colombia: Reinhabiting Memory," 110.
11 Suzanne Lacy and Pilar Riaño-Alcalá, "The Skin of Memory/La Piel del Memoria," unpublished draft essay, September 18, 2006.
12 Pilar Riaño-Alcalá, email message to author, August 26, 2017.
13 Pablo Helguera, email message to author, August 23, 2017.

result they came to understand how to represent themselves and the political implications of that self-representation.

Another important element in the work is its emphasis on movement and transition. The concept of the mobile museum grew from an understanding of the territorial divides between gangs that made it impossible for neighborhood residents to experience the work, unless it moved to areas they could safely access. This idea of mobility is poignantly embedded in the project through experiences of the participants who facilitated the project. Young teens who helped acquire the objects for the mobile museum, normally isolated in their individual areas, "were going out of the barrios, meeting with other youth and thinking of themselves as part of their city."[11] Even the culmination of the project in 1999 was based on increasing community exchange, with a series of six spirited processions that included mimes, bicyclists, stilt walkers, and pedestrians, all of whom traveled through various areas of the barrio to deliver a letter from an anonymous neighbor to each home. It concluded in a celebratory send-off for the bus, and under the mantle of this closing event, those who participated or followed along experienced freedom of movement, as they were able to visit normally unsanctioned areas.[12] This increased mobility remains a visual component of the project in the iterations that followed, through accompanying maps documenting the path of the bus.

THE SCHOOL OF PANAMERICAN UNREST: A MOBILE SCHOOLHOUSE

Helguera's recent artistic conceptualizations, books, and articles are rooted in his seminal work, *The School of Panamerican Unrest* (*SPU*). For this project Helguera erected a schoolhouse, or "nomadic think tank," at twenty-nine stops, beginning in Anchorage, Alaska, and continuing south, crossing continents, to the southernmost tip of the Americas, Tierra del Fuego. Along the way, he conducted talks, film screenings, panel discussions, civic events, and workshops that focused on

the concept of "Panamericanism"— the once prevailing nineteenth-century, utopian ideal of a unified, collaborative coalition between all the countries in North, South, and Central America. This concept has become controversial since the mid-twentieth century due to the rise of nationalist ideologies, neoliberal policies, and the increasingly dominant economic and government strategies of the United States. The discussions that Helguera instigated, which sometimes became contentious, surrounded topics such as immigration, globalism, national identity, regionalism, and art's role in society.

The School of Panamerican Unrest remains one of the most extensive public artworks to have ever been realized. Its scale and goals—to try to understand and connect seemingly disparate communities throughout the Americas—deeply affected Helguera's practice, and inspired many artists. The formative influence of the work on the artist, at a personal level, is due not only to the physical and emotional demands that surrounded it, but also to his deeper investment in pedagogy and the conceptualization of all his work thereafter:

The type of challenges and situations I encountered in my trip, and the way I was forced to respond to them, made me aware of how important pedagogy is as a tool to create meaningful communication with different communities […] It made me realize that socially engaged art, if it is to be the result of meaningful interaction, has to go beyond the nominal and the symbolic, and the listening process. It has to be earnest and sincere—not simply a blank space onto which participants are invited to have their say, but a process by which their input has direct and relevant impact in the resulting outcome of the work. This was the objective, for example, of the Panamerican Addresses.[13]

These addresses allowed anyone who wished to participate in a workshop the ability to channel their ideas, feelings, and emotions into a public statement summarizing issues facing a city and/or individual artistic communities, while suggesting potential solutions. Later

11

they were read in semi-formal presentations organized by the artist and his hosts. Although the incorporation of such pedagogical tools in art—question and answer sessions, games, and collaborative exercises, especially evident in the project's collective writing sessions—is a common occurrence now, his methods and their implementation were less prominent at the time.[14] In so doing, he created his own unique artistic approach, based on the experimentation that his project necessitated. Helguera's work encouraged other artists to consider similarly ambitious projects incorporating new forms of engagement, based on pedagogical models that foster a deeper understanding and discourse among their audiences.

Adding to the project's influence was Helguera's insistence on transparency throughout and after its conclusion. His blog and web posts plainly revealed not only the transformative, revelatory moments that occurred but also the external challenges of social practice projects, such as low attendance at an event,

car troubles, or even inclement weather. This straightforward approach allowed the public to fully grasp the rewards, intricacies, and difficulties of working in this manner. His ongoing review of the many elements of the project as it exists now—ephemera, diary entries, outside commentary, and video documentation—has helped him begin to assess this project and others like it in a broader context. His bilingual book, *The School of Panamerican Unrest: An Anthology of Documents* (2011), is an attempt at one form of assessment. Although it includes the addresses and an essay by the artist, the overwhelming majority of written contributions are frank statements about the work, some critical, by those who witnessed and participated in the project. The anthology allows both participants and public alike to evaluate *The School of Panamerican Unrest* and formulate their own appraisals. With this in mind, Helguera has offered to open the related archive of materials to anyone who wants access, with the hope that others will devise different methods of evaluation.

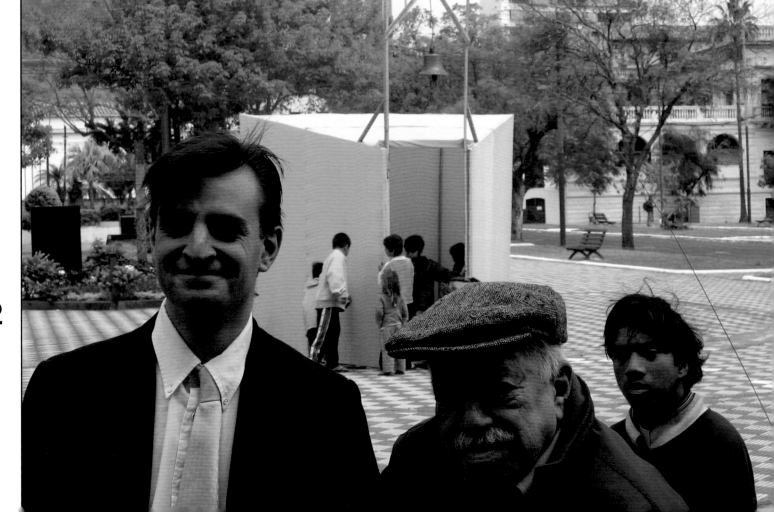

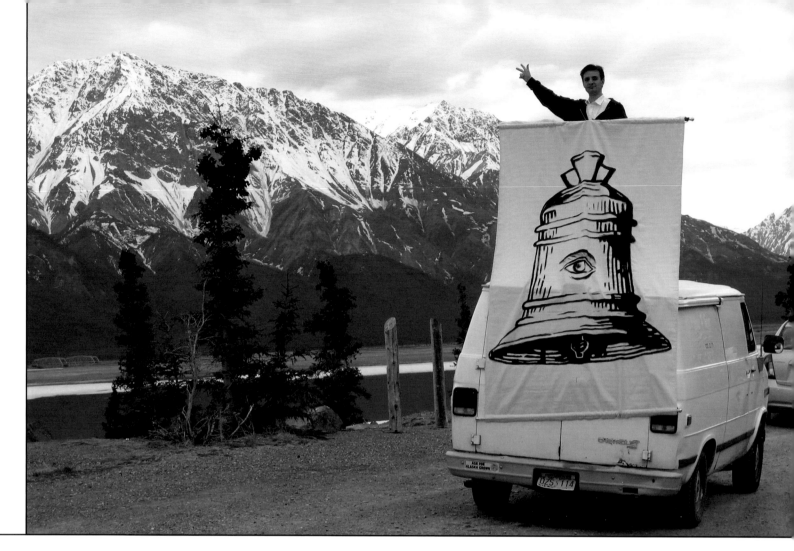

14 Pablo Helguera and Sarah Demeuse, eds., *The School of Panamerican Unrest: Anthology of Documents* (New York: Jorge Pinto Books Inc., 2011), 5.

15 Helguera and Demeuse, *The School of Panamerican Unrest: Anthology of Documents*, 6.

Movement is another explicit device in Helguera's project. That he developed a work incorporating travel isn't so unusual, considering his inclination toward nomadic endeavors. One of his earlier works, *Conservatory of Dead Languages* (2004–ongoing), involves the artist traveling throughout Mexico to record the voices of the last living speakers of native languages, resulting in a phonographic archive. Given its epic scale, *The School of Panamerican Unrest* is certainly an extreme example of this interest in travel:

> I decided that, in order to be consistent with the comprehensiveness of the premise, I had to drive with the school down the entire Pan-American Highway. The idea in part, was to give attention to the expected "capitals" of the art world (Los Angeles, Mexico City, Buenos Aires, etc.) but focus equally on locations outside of the regular routes of art-world biennials and art production.[15]

The unbroken continuity of his journey helped him remain focused on the concepts and ideas engendered by the myriad conversations he was having and witnessing. As he frequently states, central to the project were those interpersonal encounters, and his ability to share those experiences with others along the way. The project ended up being a unique snapshot of the concerns, fears, and joys facing communities and artists in different places at a specific moment in time.

Both *Mobilizing Pedagogy* and *The Schoolhouse and the Bus* demonstrate how two renowned socially engaged artists, Suzanne Lacy and Pablo Helguera, have approached the field. Their foundational projects utilize differing but complementary methods to positively impact communities through engagement, pedagogy, and mobility. This book and related exhibition function as a lens through which visitors can examine the universal issues addressed by the artists. Just as importantly, the exhibition provides an opportunity to learn more about the genre of social practice that is increasingly playing a larger role in both art and society.

13

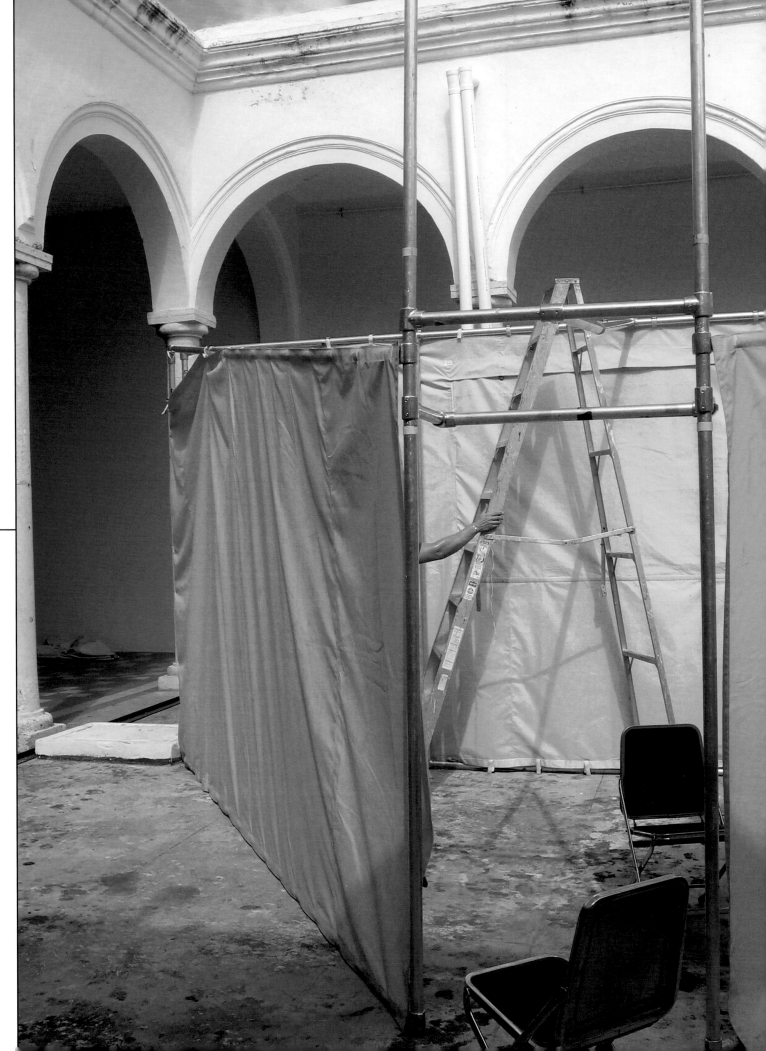

14

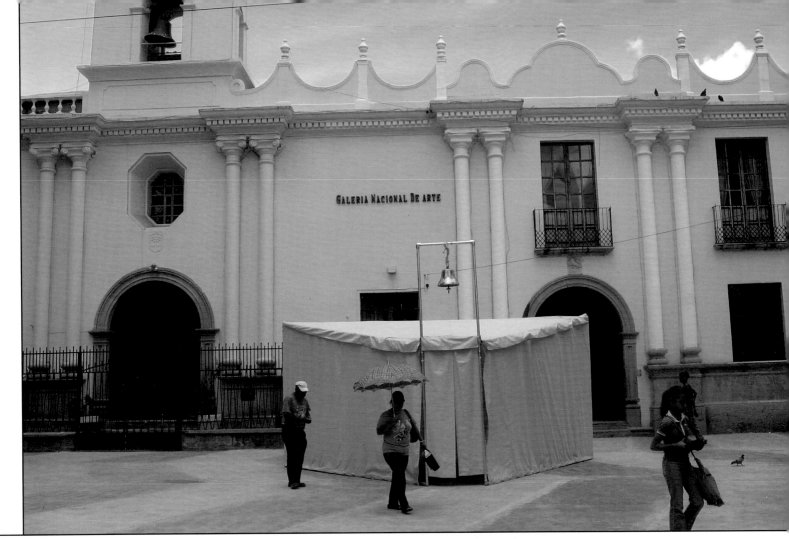

08 *Skin of Memory*, 1999. Photo by Suzanne Lacy.

09 *Skin of Memory*, 1999. Photo by Carlos Sanchez.

12 Pablo Helguera with Paraguayan sculptor Hermann Guggiari at the Plaza del Cabildo, Asunción, Paraguay, September 2006. Photo courtesy of the artist.

13 Pablo Helguera near Tok, Alaska, May 2006. Photo by Sean Arden.

14 *SPU* schoolhouse at the School of Fine Arts in Mérida, Yucatán, June 2006. Photo courtesy of the artist.

15 *SPU* schoolhouse at the Plaza de la Merced, Tegucigalpa, Honduras, June 2006. Photo courtesy of the artist.

THE SCHOOL OF PANAMERICAN UNREST

PROJECT DESCRIPTION

BY HOLLY GORE

The School of Panamerican Unrest was a social practice art project and mobile think tank. Initiated by Pablo Helguera, a Mexican artist based in New York City, it investigated current sociopolitical issues in light of nineteenth-century utopian ideals of Panamerican unity. The crucible for its development was the post-9/11 United States, an environment marked by patriotism, guardedness, and militaristic policies such as the Bush Doctrine, which authorized preemptive attacks on other countries in the name of national security. By contrast, *The School of Panamerican Unrest* (SPU) sought to encompass the sprawling narratives of the Americas—North and South—and, in doing so, promote intercultural understanding.

Piloting in Zürich in 2003, *The School of Panamerican Unrest* centered around a wooden schoolhouse erected in the gallery, in which Helguera held discussions on topics relating to Panamerican identity. A grant from Creative Capital allowed the project to expand into a major work of public art. In the spring of 2006, after an inaugural ceremony on Ellis Island, Helguera flew to Anchorage, Alaska, and from there took *The School of Panamerican Unrest* on the road. From May 19 to September 15 he traveled approximately 25,000 miles by van on the Pan-American Highway to Tierra del Fuego at the southernmost tip of South America. Along the way, he made twenty-nine official stops, putting on film screenings, lectures, and workshops that explored issues such as immigration, housing, urban development, and the social role of artists.

The visual centerpiece of the nomadic *SPU*, a collapsible schoolhouse made of steel pipe, yellow canvas, and an iconic brass bell, grounded the work under the rubric of pedagogy. The *SPU*'s educational methods incorporated games, dialogic strategies, and inquiry-based learning. Local hosts identified crucial issues facing their city as topics for discussion. At times Helguera acted as the workshop's secretary, by facilitating the writing of a "Panamerican Address," a document signed by its multiple authors, expressing their hopes and fears for the future of their city, and identifying opportunities for activism.

The strenuous and sometimes dangerous trip down the Pan-American Highway was a one-time event for Helguera, yet a public presence of *The School of Panamerican Unrest* persists. To brand his project, Helguera created banners bearing the emblem of a bell with an eye, an image that speaks to symbols of freedom used throughout the Americas such as the Liberty Bell in the United States, the Bell of Dolores in Mexico, and the Independence Bell that figures in the histories of some Central American countries. The banners were hung alongside the schoolhouse at each of the twenty-nine stops, transforming museum galleries and city squares into ceremonial spaces at which speeches were made, Panamerican Addresses read, and a "Panamerican Anthem" played. These rituals continued off route **17** in postscript "stops" in cities such as New York and Santa Barbara, California. Upon completion of the original journey, Helguera began *Panamerican Suite* (2006–ongoing), a series of collages that wrestle and play with the concept of Panamericanism.

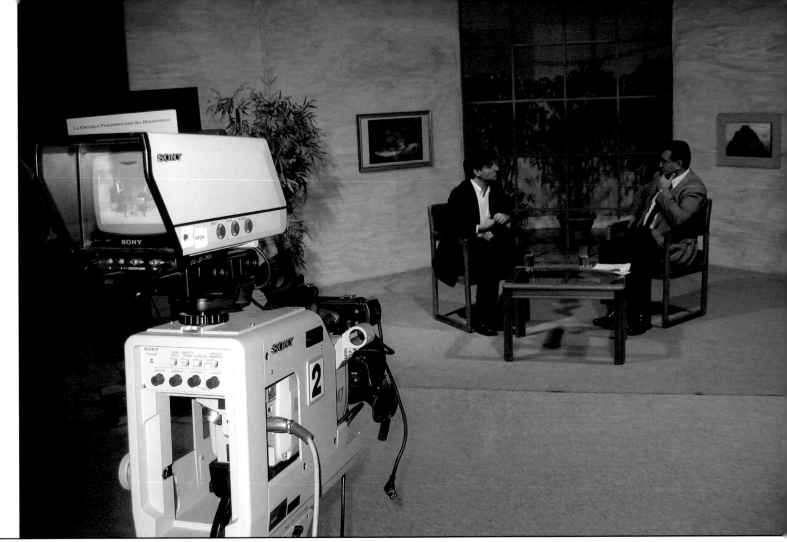

18 San Salvador, El Salvador. Photo courtesy of the artist.
19 Pablo Helguera in television interview, San Salvador, El Salvador, June 2006.
 Photo courtesy of the artist.

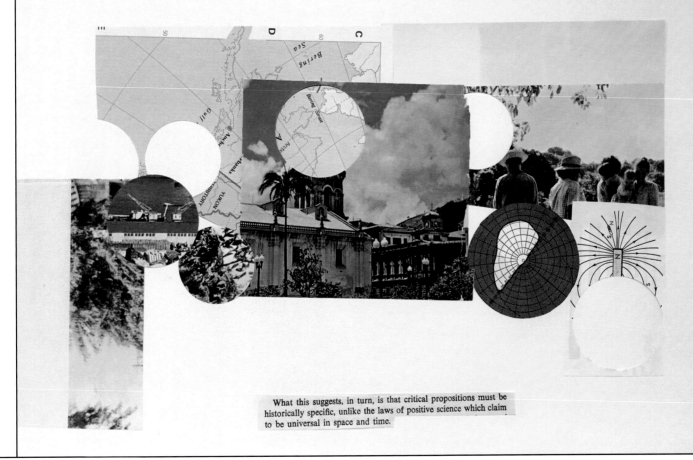

What this suggests, in turn, is that critical propositions must be historically specific, unlike the laws of positive science which claim to be universal in space and time.

20 *Untitled*, from *Panamerican Suite*, 2006. Collage on paper, 9 x 12 in. Courtesy of the artist.
21 *Principles of Efficient Dealing with the Environment*, from *Panamerican Suite*, 2006.
Collage on paper, 9 x 12 in. Courtesy of the artist.

Fig. 154.—Two-phase, four-pole, parallel connection.

After the disturbance began, things happened rapidly.

22 *Two-phase, four-pole, parallel connection*, from *Panamerican Suite*, 2006.
 Collage on paper, 9 x 12 in. Courtesy of the artist.
23 *The Call of the Spring*, from *Panamerican Suite*, 2006.
 Collage on paper, 9 x 12 in. Courtesy of the artist.
24 *I saw herds of thousands of wild beasts grazing in soundless peace...*
 from *Panamerican Suite*, 2006. Collage on paper, 9 x 12 in. Courtesy of the artist.

23

I saw herds of thousands of wild beasts grazing in soundless peace, beneath the breath of the primeval world, as they had done for unimaginable ages of time, and I had the feeling of being the first man, the first being to know that all this *is*.

JOURNEY NOTES OF PANAMERICA: THE SOCIAL PRACTICES OF ART

A CONVERSATION BETWEEN ARTIST PABLO HELGUERA AND ADETTY PÉREZ DE MILES

APM Would you ever consider undertaking a performance like *The School of Panamerican Unrest* (*SPU*) in the future? And if you did, how you would do it differently?

PH I most definitely do not consider it a performance piece, but a socially engaged art project. It consisted of a series of actions or activities that would be impossible to repeat because of the specific context and time within which they happened. So repeating this trip would mean something completely different, apart from the fact that I am in a different stage in my life, where I feel I could not undertake such a project, knowing what I know now.

 Latin America has also become a very destabilized region in some places. For example, I don't think I would be able to safely go to Venezuela at this point. But, most importantly, what would be the objective of repeating the journey myself? I would not mind if someone else were to undertake the same journey. In fact, it would be really interesting for someone else to do it. Because it would be a different person, a different time, a different perspective, for whom and which all I did was offer, perhaps, a model.

APM How did the work of Suzanne Lacy and that of Juan Downey, such as *Video Trans Americas* (1976), which documented his travels from North to Central and South America, inform your practice or the thought-process behind *The School of Panamerican Unrest*?

PH I knew Suzanne's work at the time and admired it, and had been told about Downey's work while planning my trip, yet his intentions and purposes seemed to differ from mine, and I still feel that way.

 I should stress that artistic genealogy was not at the top of my concerns at that moment. I was mainly reacting to the events of the moment— the post-9/11 foreign policy (known as the Bush Doctrine) that had emerged then, and I was thinking a lot about the role that the US played in trying to shape the "world order." I was also thinking about education, which is why, generally, it is difficult for me to discuss this project as an artist-centered, conceptual activity. In executing this project, my job was the one that I normally play: an educator. In the process of education you are not there to talk about yourself, but rather external issues. The personal impact, implications, and emotional involvement were so powerful, however, that this impact was impossible for me to ignore, though I tried. But when I completed the *SPU* and returned home I realized that I had a lot to process in that regard.

 I still think that, if anything, the value of the project lies in the conversations that took place and the kind of debates that it triggered surrounding nationalism, regionalism, and national identity—and more specifically about the question of art's role in constructing or deconstructing national identity. While there was definitely a travelogue aspect to it, to me at the project's core were those encounters, those conversations with people. It was about them and their views of the world in that moment.

 I would like the project to exist in collective memory, as a snapshot of a period in the Americas.

APM One of the things that I thought was important was precisely a notion of time and space: how the reception of the work and engagement with the work differed in North, Central, and South America. In North America, north of the Mexican border, there seemed

to be an emphasis on the function of art. What different types of engagement did you see with the work, for example, in New York versus Honduras?

PH I noticed in general, first, the willingness and desire of local communities to engage with and entertain my ideas of how to do the workshops, which was very important. When I arrived in a particular location, I proposed a certain structure to my visit: First, I would develop, in collaboration with the local host, a topic for a panel-style discussion. The following day I would run a workshop that resulted in the collective writing of the Panamerican Address, or a proclamation inspired by the discussions we had the previous day.

APM What caught my attention in some of the conversations at *SPU* events was not so much the discussion of the "instrumentalization" of art but rather discussions of cultural capital, the labor of internships, and the work that goes on behind the scenes to create a massively produced piece like this one. There was suspicion and questions in places like New York and Argentina—who is the work for, and who benefits from it? At the same time, there were people genuinely interested in talking about your work in relation to their own context. Does that make sense?

PH The question of how an artist benefits from any socially engaged artwork is always present. To an extent, it is conceivable that an artist might be taking on a particular social cause to improve his or her standing in the prestige economy and (or going even further), that this artist might be more interested in getting credit for what they do rather than in the actual results a project generates. I don't think an artist can, or should, ever try to hush those criticisms; nor are we ever exempt from receiving them. For that reason, in my view, the only thing one can do is to go about their work with sincerity and integrity, and hopefully the work will be recognized as more than a superficial, self-serving gesture. I have also argued in other places that artists can never "disappear" as authors or instigators of a socially engaged project because authorship also means accountability.

In various places I received criticisms about the project and/or the "covert agenda" that some perceived in it. But there was no covert agenda. The project was plainly laid out to the participants wherever I went. Interestingly, in places like Argentina, Venezuela, and Colombia, the critical reactions of some artists, which were videotaped, ironically described the precise political and cultural juncture that some of these communities were undergoing at the time. In cases such as in Buenos Aires, where artists wanted to debate the notion of "debate," the dynamic and meta-meta-meta-analysis that took place showed how an obsession with critique, while stifling and unproductive, was also representative of the local critical discourse.

27

APM Although I think there were parallels between some of the art capitals like New York and Argentina, the sensibility of each place was also different. For instance, in Tegucigalpa there was a great desire to engage with you and with the *SPU* as an art project. We've talked a bit about your interest in collaboration, and how communication is at the center of community-building. How did your collaborative or communicative goals change as you were going through the process of the artwork?

PH Some aspects of the project evolved as the trip unfolded. For example, when I started these debates and discussions in Alaska, I did not initially think of the idea of inviting people to write a collective address. This evolved naturally as part of a process that, to me, became increasingly important because it made sharing the consensus of discussion and ideas from every place with the other locations not only possible but also our goal. We published the addresses on a blog, since it was before social media, and communication was not as fluid as it is today

In order to accomplish that goal, I counted on people's willingness and desire to be part of the process, even if only to humor me. Many times that didn't work out because people were not so interested in being a part of it, or because people didn't show up, or because people wanted to talk about other things. So, in some places, I wasn't able to do the address in those workshops. The point is that my goals started to become clear as I interacted with these communities, and so the project had the potential to connect different cities. We had a number of instances where people in other cities were following what we were doing—they were excited to welcome us and had great expectations. They were getting ready to do their own presentations once I got there.

APM You situate the work clearly within education or within the pedagogical impulses of art. How were these pedagogical impulses and identifying yourself as an educator an important part of the work? I think that there's a lot of talk about the pedagogical turn in art, but how a work is pedagogical is not often defined. What are some of the characteristics that give the work the pedagogical impulse that you often write about and talk about in relationship to this project? How does the pedagogical impulse in your work impact or mediate the work of the *SPU* in ways that it might not if it didn't have that component?

PH I think it has to do with the idea of outcomes. When I started the project and called it *The School of Panamerican Unrest,* I was explicitly thinking about my own professional involvement with museum education. Specifically, the objective was to employ a pedagogical discursive process to elicit a collective response. In other words, debates and workshops were the approaches through which we would reach a collective reflection that would later become public.

It was important that there were actionable items that resulted from the conversations. So the Panamerican Addresses became statements of purpose, as well as an outcome of the project, or a way in which the discussions could turn into something specific. In the discourse of critical pedagogy you could see it as a statement of *conscientização*, Paulo Freire's term for critical consciousness.

Each address was meant to be a collective statement about a reality that was considered present at the time. So that was a very simple way in which pedagogy informed my thinking. Thinking about how the project had to change and adapt, it was a huge challenge to consider all of the different ways in which the project could take place. I had to use everything that I knew about being an educator at the time to make things work. In education you have a toolbox of approaches and methods that you can employ depending on the circumstance. If I were in a gallery speaking to a group of people with PhDs in art history,

it would be completely different to working with a group of kids who had never been to a museum before. You need to learn to use the appropriate structures to have a conversation that will be meaningful to that particular group of people of art.

It's less an issue about how much you know of a subject and much more an issue of how you are able to construct a conversation or debate on a particular subject. In the case of going to these different cities, I was obviously the least knowledgeable person in each one of those places because I was the visitor, the tourist, I guess. At the same time, however, I could use my own ignorance in a productive way by inviting those to tell me, "How would you describe this place in five words?" Things like that. The responses from each of them were fascinating, and what they disagreed on was even more fascinating.

APM Your pedagogical approach here is very much centered on critical pedagogy, and also it reminds me a little bit of Jacques Rancière's *The Ignorant Schoolmaster* (1991). That is not without its tensions; there have been some critiques and misreading of Rancière's work. Still, the figure of the ignorant schoolmaster calls our attention to ways in which educators summon students to use their own intelligence, without attempting to impose expert knowledge on their learning. Modes of education that rely on authoritarian knowledge presume that the learner is unequal and, therefore, less capable than the expert, which, according to Rancière, has a stultifying (or perhaps stupefying) effect on learners that is oppressive rather than emancipatory. This outlook is contiguous in part with Freire's writing on non-hierarchical and collective learning. Your pedagogical approach avoids a deficit-based understanding of the knowledge of a community; instead, *SPU* moves beyond an education that is top-down…

PH *The Ignorant Schoolmaster* was very much in vogue in some art circles when I did my trip, yet I confess I have an ambivalent relationship with it. I appreciated Rancière's arguments and even felt vindicated by my approach as a generalist educator who works in museums. With that said, I also felt that the book opens the door for many misinterpretations of what education can be, the worst of which suggests that one doesn't need any expertise to teach (which I don't think was Rancière's message in any case). It goes without saying that there is a difference between not knowing a subject that you have to teach and not knowing how to teach. And paradoxically, being an "ignorant" schoolmaster is more difficult than being a supposedly "learned" schoolmaster who teaches with conventional methods.

In a sense, I remained adamant that I was there to help the group construct their own ideas. I was the ignorant schoolmaster, who helped them give shape to their statements without telling them what statement to write.

29

APM How did your experience with *The School of Panamerican Unrest* inform your work and your book *Education for Socially Engaged Art* (2013)?

PH *The School of Panamerican Unrest* was the most important project in my development as an artist. It informed my thinking about education, social practice, public art, and the role that art plays in our society. Remember, these were the early years of social practice. Now, we see it in a historic way, but at that time we were not really using the term "social practice." In fact, I remember my first meeting and

conversation with Claire Bishop in London two years before my trip. Though she told me that she was researching this type of art form, it was not a phrase that we, as its practitioners, regularly used.

After the trip, I was invited to lead a class at Portland State University taught by Harrell Fletcher and Jen Delos Reyes. Harrell had established an important social practice program at PSU. I also taught at the social practice program started by Ted Purves, who unfortunately passed away recently. Those initial experiences of teaching social practice showed me that there was a great need to articulate some of the guiding principles of social practice. That's what led me to write the book *Education for Socially Engaged Art*, which was my attempt to describe how these approaches or educational methods can work in the creation of a socially engaged experience.

We are so invested in this objective interpretation of art that we think it is impossible to measure the impact of an artwork on the world. I felt that, if anything, social practice should be a commitment to verify that what you're doing in fact has an impact in the world. It is not about the good intentions; it's about actual impact in places and communities and in reality.

APM The notion of "verifying" the impact of a work of art is quite complicated. Can you measure the impact of a work of art?

PH That is what I think distinguishes social practice from performance. Performance art to me is a discipline, and it's an art form that gives physical reality to various ideas. Those ideas happen in the world, but in the end they still are read in the symbolic realm of art, whereas in social practice, you have to insert yourself in reality and affect it outside of the protective definition of art. It doesn't work to say, for example, that you are creating a school if you're not teaching anything—that is, if it is not actually educating or functioning as a school. It doesn't work to say that you're doing a music project if you don't play the music. In these cases, you're not doing social practice; you are creating a symbolic representation that is not dissimilar to painting. There's nothing wrong with that, but it should be acknowledged that it is a symbolic representation, not a direct engagement with the world.

An artist should establish what they're trying to accomplish and how to go about it, and then figure out what impact it has. There is a whole set of evaluation criteria that you use in museum education to know things: what drove people there; if anything changed in their thinking after the experience; if they would do it again; and questions that are not yes/no questions but open-ended, providing a more complex and nuanced understanding of where this person was emotionally or mentally before the experience, as well as after it. You can determine whether you had any impact.

Artists often argue that they don't want to be subjected to bureaucratic standards of effectiveness because that would limit their creativity, but this argument is weak. If you have a mission you have a purpose, and this purpose can and should be evaluated. If you do a political piece that intends to get people to reflect on the happening of the country, then ostensibly you want people to reflect on this thing and not on something else.

APM In the art world we talk about participatory art practices, but often the audience or the participants are excluded from the conversation.

PH *The School of Panamerican Unrest: An Anthology of Documents* (2011), a book that I edited in collaboration with Sarah Demeuse, has this evaluation as a goal. With that in mind, I invited people to speak about their experiences. Not everybody had nice things to say; some of them were very critical, but that was okay with me. I felt that's what it is: it's the public evaluation of the projects. The most important thing is the ability to create a transparent process by which the participants can provide their feedback and not as an art review. You can witness the meaning of the experience to them. Still, we as practitioners have a lot left to do with regard to how we evaluate public experiences.

APM How do you, as an artist, go about doing that, or are you leaving that work for someone else?

PH I feel I have reached a point where all I can do is provide the entire archive for others to make those assessments. Every time I tried to exhibit the project, which is indeed massive, I confronted issues like how to accurately communicate what that experience was and what happened. I have decided that the best I can do is to offer the entirety of the documentation, as an archive, to people who may want to explore it, allowing them to draw their own conclusions. I think in the future, there will be people who will have different methods of assessing impact. They will probably have a better sense of what was helpful, interesting, or meaningful about those experiences.

As an educator and artist, I believe that we are, by nature, outsiders, and that the notion of the artist who speaks exclusively about individual experience belongs to a modernist tradition that we have to overcome, because we speak to and about experience, and human experience is universal. I am trained to work with other people's perspectives and views of life. Individuals around the world share many more things than they think. In other words, culture does not make us Martians or complete extra-terrestrials to one another.

APM The notion of a nomad is used in theory, art, and academia without much examination as to how it can help raise questions of who has privilege. The type of privilege I'm referring to comes with being an artist: associated cultural capital and money granted. Although artists often struggle to get grant money to support their projects, this type of privilege allows artists to travel, to be nomadic.

PH I was confronted with my privilege at every stop, and more so when I was in Latin America. In places like Colombia, for example, I realized at some point that part of the reason I was resented—at least I suspected—was because I was a Mexican artist based in New York City, with this ability to have mobility throughout the continent.

I was very aware of the fact that I had support from a significant foundation, Creative Capital, to do this project, and I was repeatedly reminded of this financial privilege. At the same time, it became a boring discussion: Yes, I have the ability to do this—so what? Let's move on. To me, it didn't matter at all who I was; what mattered was that we were there to have a discussion. Transparency about it was a necessity, one that goes back to critical pedagogy and to Freire, who did not hide his privilege. He would say, and I paraphrase here, "Well, I have been given this opportunity to be in this place where

I can be a teacher, and I have this knowledge that you might not have, but sometimes you have knowledge that I don't have." It was a direct acknowledgment that I always tried to convey during the project. Despite the funding, I carried out the project with hard work and a tight budget. Many times I was completely stranded with no money, and it was very stressful at different times.

APM In moving forward, what did you learn in this process? What would you like to continue to do or advance, regarding this project? Are there things that you wouldn't do again?

PH Yes, perhaps. As you get older, you develop thicker skin and learn not to become too emotional. I think the process of social engagement in art is still a fairly new to artists. We are not yet entirely capable of dealing with it emotionally. I know this from artist friends who have also engaged in projects that are really powerful and transformative, but sometimes difficult to assimilate. These projects result in emotional trauma, which we are ill equipped to deal with.

APM Well, I think what I hear you say is that the *SPU* affirmed the importance of social practice as a method for you, a method of living, with some caution here—the emotional impact of the work—but you survived it!

PH More and more, social practice is simply becoming social justice, art for social justice. That's fine—except that in the process of politicizing the practice, we need to ask ourselves: Why is it important for it to continue being art? That is something I wish we could reflect on a little bit more. What is it about its identifier as artwork that makes it meaningful and worth producing in this way? Or should we completely forget about it as art and become activists? Those are some of the questions that we will be have to deal with in the future with socially engaged art.

Another key discussion that we're having right now is how do you activate these practices. We ask ourselves: What are the standards for communicating these ephemeral forms to a third audience that was never part of it in the first place? How do we communicate what happens? How do museums that traditionally collect, preserve, and display objects engage with these art forms, and how might they "preserve" the ideas behind them for future knowledge? Those are some of the questions that need solutions, or approaches to solutions, especially as we try to historicize this practice.

APM This is why the work of the curator is so important. I think that they are not only doing all of the above but also trying to reach a third audience. They are thinking about how these "standards" are communicated, while addressing how these practices become legitimized. A similar process occurs when art is being professionalized. I think there's a great deal of room to continue to work in these directions from multiple perspectives.

PH Absolutely.

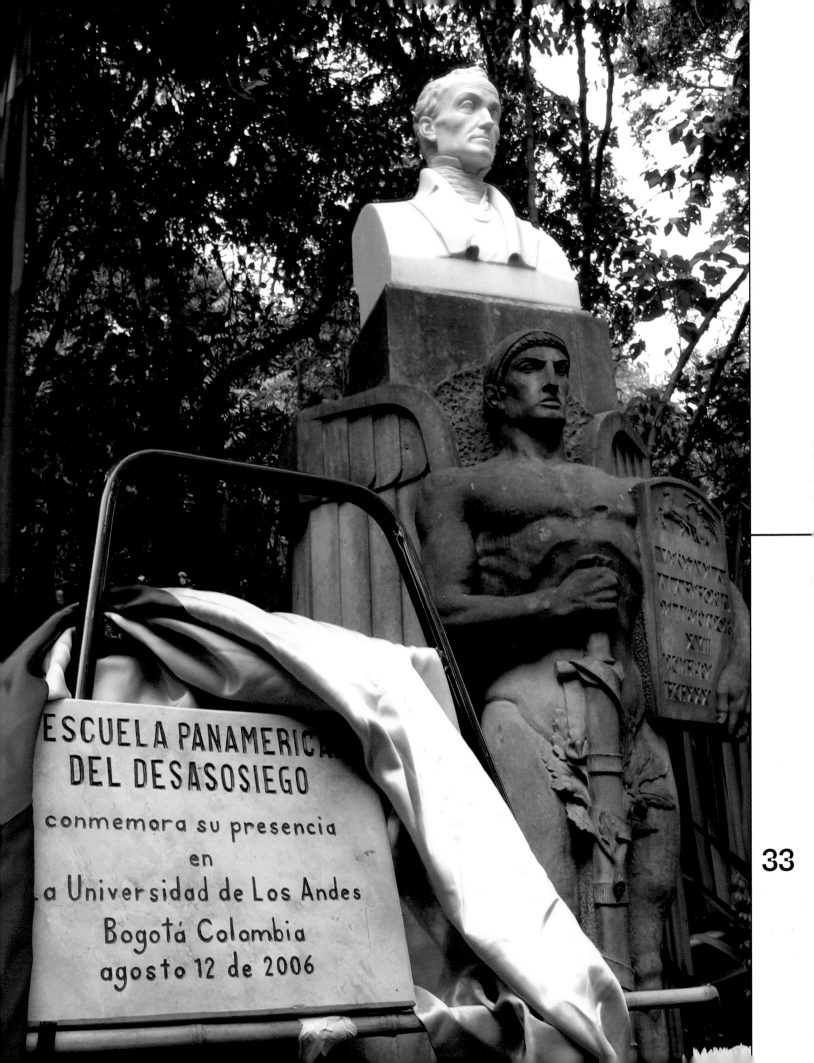

33

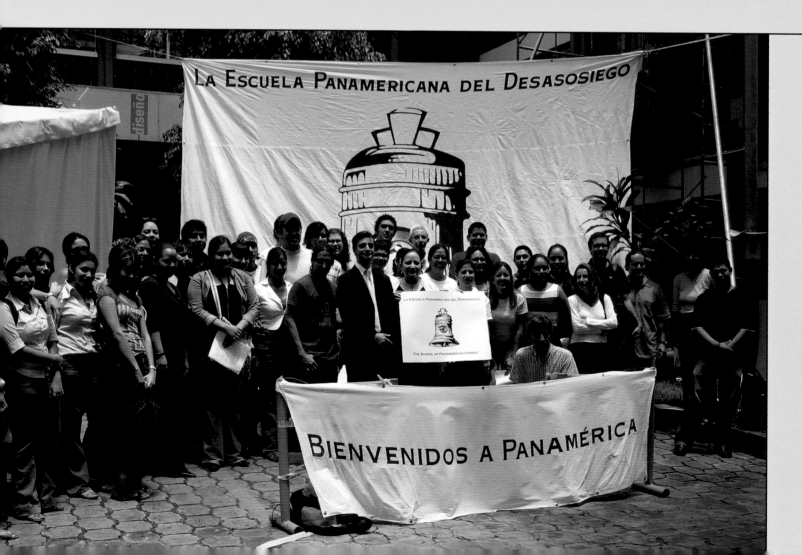

33 Quinta de Bolívar, Bogotá, Colombia, August 2006. Photo courtesy of the artist.

34 Panamerican ceremony at the Universidad Matías Delgado,
San Salvador, El Salvador, June 2006. Photo courtesy of the artist.

35 Pablo Helguera at a Panamerican ceremony, Casa del Lago,
Mexico City, June 2006. Photo courtesy of the artist.

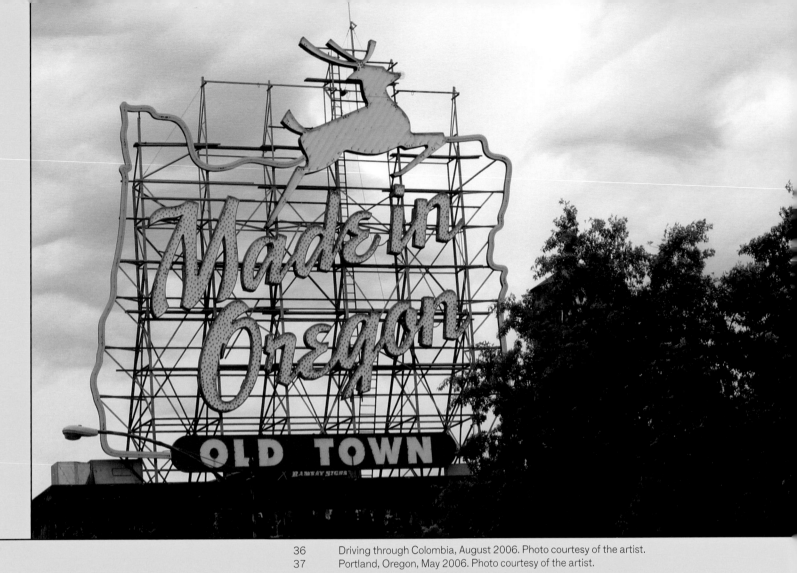

36 Driving through Colombia, August 2006. Photo courtesy of the artist.
37 Portland, Oregon, May 2006. Photo courtesy of the artist.

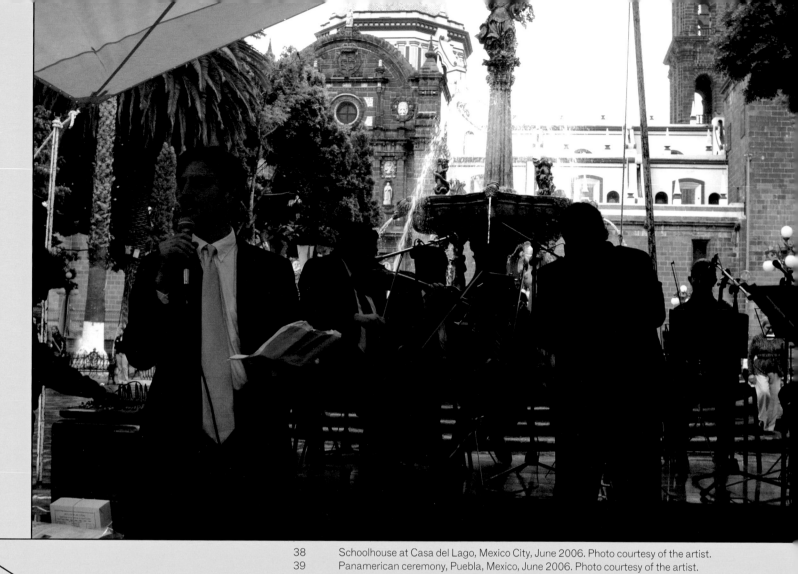

38 Schoolhouse at Casa del Lago, Mexico City, June 2006. Photo courtesy of the artist.
39 Panamerican ceremony, Puebla, Mexico, June 2006. Photo courtesy of the artist.

40 El Amatillo (El Salvador/Honduras border crossing), June 2006. Photo courtesy of the artist.
41 Pablo Helguera on the highway, Canada, May 2006. Photo courtesy of the artist.

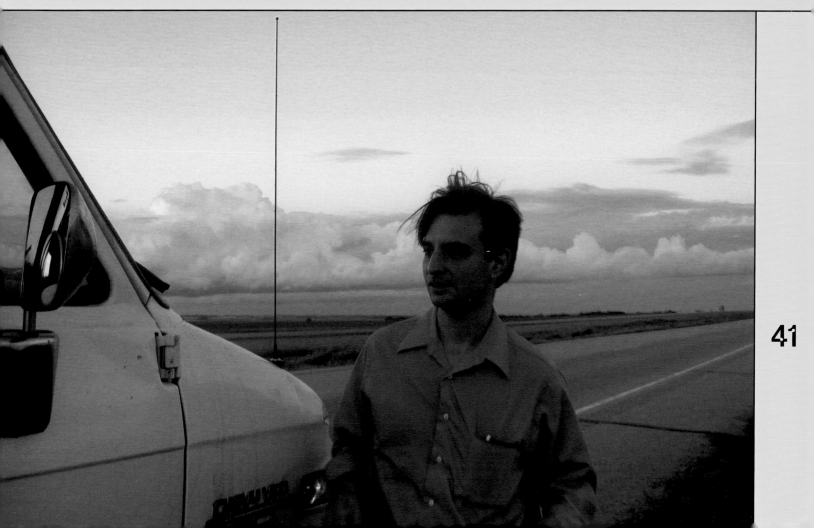

41

OBJECT LESSONS:
THE ROLE OF MATERIAL CULTURE IN SOCIALLY ENGAGED ART
BY SARA REISMAN

1 Lucy Lippard, *Six Years: The Dematerialization of the Art Object from 1966 to 1972* (Berkeley and Los Angeles: University of California Press, 1997) (original printing 1973), xxii.

2 Interview between Suzanne Lacy and Pilar Riaño-Alcalá, September 18, 2006.

The Schoolhouse and the Bus: Mobility, Pedagogy, and Engagement is an exhibition that presents two artistic projects that encapsulate a process of translation between the unruliness of lived experience and the formulas of exhibition practice. In organizing such an exhibition, in dialogue with the artists, we as curators were forced to question how socially engaged artwork can be translated—physically, spatially, and spiritually—into the often stagnant, neutral space of a gallery. How do objects that are byproducts of an artistic process figure into the presentation of an ephemeral, relational project? To what degree does the archive of an artwork become the work itself? Featured in the exhibition are maps of Medellín and of a journey across the Americas, collages, on-the-road documentary footage punctuated by collective declarations made by community members of twenty-nine cities, video interviews with residents of Medellín, souvenirs, ephemera, and records including news articles, letters, and blog posts. These materials, some conceived as artworks, others selected to recreate an out-of-reach context, point to two projects that differ in scale, duration, and atmosphere. Larger structures have been restaged—the yellow fabric tent of a schoolhouse and an illuminated shelf displaying personal affects—to reflect the elastic characteristics of time and place, as a partial manifestation of the lived experiences that continue to comprise two socially engaged projects. Suzanne Lacy and Pilar Riaño-Alcalá's *Skin of Memory* and Pablo Helguera's *The School of Panamerican Unrest*, originally realized in 1999 and 2006 respectively, intersect conceptually within the exhibition *The Schoolhouse and the Bus: Mobility, Pedagogy, and Engagement*, having been informed by and produced within the broader geographic frame of the Americas, and specifically Medellín, Colombia.

From the beginning, both Helguera, Lacy, and Lacy's collaborator Riaño-Alcalá, questioned the efficacy of relying heavily on the display of objects to adequately capture and represent their respective works. Questions surrounding the limitations of conventional exhibition making are acutely raised in the context of socially engaged artistic practice, where the desire to show the work, and the experiential and relational nature of the artwork, are often in conflict with the means of translating the experience into a display. Indebted to the legacy of conceptual art, artists and curators are continuously compelled to attempt this process, whether it is for visibility, legacy, art world legitimacy, or a more engaged notion of pedagogy. As Lucy Lippard has noted, "Conceptualists indicated that the most exciting 'art' might still be buried in social energies not yet recognized as art."[1] Integral to any true avant-garde artistic gesture, these energies can contribute to an object being unrecognizable as art. The unknown artwork—its unknowability—can sometimes signal its potential for radicality, still raising the age-old question, "but is it art?" Even if we feel certain that it is art (because we say so), it is always worth questioning the impulse driving us to display works of art, since these social energies can never be fully re-presented as they were originally realized. As challenging as it may be to grasp and resolve these endeavors as art, the opportunity to learn from ephemeral practices, particularly human exchange, has become increasingly urgent in times of political and social instability.

Leading up to *Skin of Memory* (1999), artist Suzanne Lacy was approached by Colombian anthropologist Pilar Riaño-Alcalá to collaborate with a team that included architect Vicky Rameriz, designer Raul Cabra, and local artisans, contributing to a process conceived to "find alternatives to violence and strengthen civil society" in Medellín's Barrio Antioquia, an area ravaged by increasing violence related to the drug trade. Riaño-Alcalá invited Lacy to work within the community based on the sustained engagement and success of her decade-long *The Oakland Projects* (1991–2001). Staged in eight parts, *The Oakland Projects* included *The Roof Is On Fire* (1993–1994), which explored the tensions between youth and the police in Oakland, California, and *Expectations Summer Project* (1997), which examined the personal and political impacts of teen pregnancy. Lacy's multilayered approach to engaging local youth on issues concerning their well-being—health, education, safety, and public policy—interested Riaño-Alcalá,

43

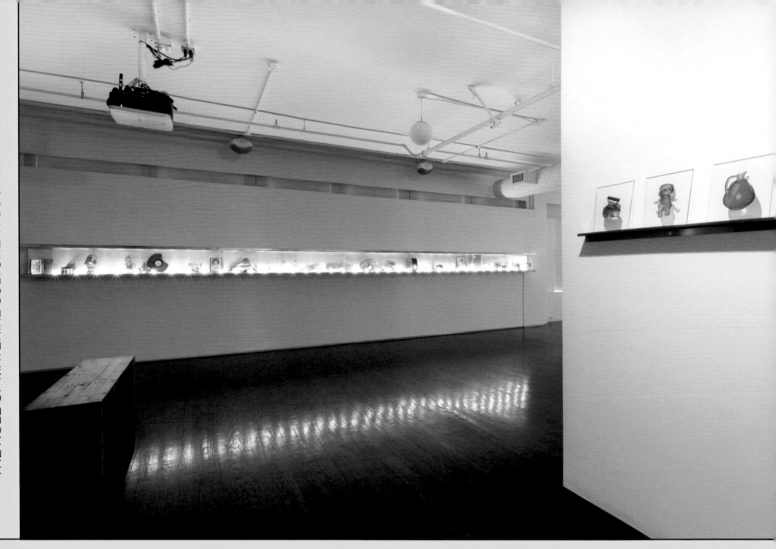

who, at the time, was organizing on the community level in Medellín in response to the needs of neighborhood youth, whose experiences were fraught with the trauma associated with localized violence. The parallels between youth cultures in Medellín and Oakland are based in what Lacy and Riaño describe as "unprocessed personal losses"and "consequent paralysis and violence."[2]

In 2003, artist Pablo Helguera began planning a four-month journey titled *The School of Panamerican Unrest* (2006), which would result in a road trip across the Americas. Beginning in Anchorage, Alaska, he concluded in Tierra del Fuego, Argentina, having made twenty-nine stops across two continents. At each stop—in places like Mexico City, Bogotá, Vancouver, Calgary, Mérida, and San Salvador—Helguera set up a mobile schoolhouse, where he collaborated with local organizations and individuals in participatory workshops, that were a hybrid of performance art and experiential education. Featuring readings, performances, and lectures,

they were shaped by the people involved at each location. Motivated by what he has described as a lack of communication between different countries within the Americas, Helguera's project offered an opportunity to draw connections between the vast diversity of cultural communities that make up the continent. In order to reveal the potential relationships between these varied geographic locations, Helguera worked with local participants at each site on a community-specific basis to articulate the role and possibilities of art and culture to address the social, political, and economic issues of that moment in 2006.

The installation of Lacy and Riaño-Alcalá's *Skin of Memory* is anchored by the display of a collection of personal objects, that collectively function as a community memorial. Originally presented in a bus in Medellín, the "museo arqueologico del Barrio Antioquia" was a mobile commemorative exhibition that travelled to different parts of the Barrio, crossing contested boundaries rather than having residents risk the trip, in order to safely share

the project with different communities. It displayed 500 items selected and offered by participants, including currency, figurines, identification cards, stuffed animals, toys, jewelry, household items, and the clothes of those killed in shootouts. Within *The Schoolhouse and the Bus*, the objects featured in the mobile museum have been reduced to a partial installation of ephemera retrieved from individuals in Medellín who contributed objects in 1999, flanked by video documentation of the project. Adding to the viewer's experience, Lacy and Riaño-Alcalá present maps, news articles, and a timeline in order to enrich our understanding of this conflicted period in Barrio Antioquia.

At the center of Helguera's installation of *The School of Panamerican Unrest* is a yellow schoolhouse. Inside, an hour-long documentary of Helguera's odyssey begins with him reflecting on then-recent events leading up to his project: September 11, the Iraq War. In the video, he posits, "I wanted to understand how the American ideals of peace, brotherhood, and unity had evolved to a project of global hegemony, and I felt that we needed to look back at history at the time when the conscience of the new world had been founded. Where were those 19th century ideals of perfect American democracies imagined by leaders like Jefferson and Bolivar? Where was the America described in the poetry of Walt Whitman and José Martí?" Like the personal affects that comprise Lacy and Riaño-Alcalá's project, Helguera's archival material is, at times, absorbed into his artistic output. His series of collages, *The Panamerican Suite* (examples at pp. 20–24), were made in a restorative, therapeutic effort, following the conclusion of the 25,000 mile trip, which left him physically and emotionally drained. They comprise maps and scientific and mathematical diagrams, with captions excised from book pages.

IT SEEMS ALMOST THE SAME WAY WITH COUNTRIES AS WITH PEOPLE.

WE WILL BE HEROES TOGETHER.

IT INVOLVES A SENSE OF INNER TIME, AN INWARD PERSPECTIVE.

These statements read like a postscript, musings and reflections on Helguera's rigorous itinerary. If we recognize that objects are limited in their capacity to re-present or capture a project, to create an atmosphere, or impart the experience of being there, are there other ways of understanding the transformative potentials of a socially engaged artwork? One approach might be to reconstruct a scene and invite the public to experience a simulation. Another might be to restage a similar project in a new place, with information about the original artwork. Additionally, we can attempt to capture some of the ripple effects of said project, to assess what, if any, connections can be made in terms of the its subsequent impact and legacy.

The problem with determining impact is that social practice as an art form is continually in flux, both materially and procedurally, and does not necessarily follow a scientific method of research and evaluation assessable by standardized criteria. As an art form, our understanding of the best practices in re-presenting any socially engaged artwork is contingent on its particular components, characteristics, and relationship to context. While it is important to make a distinction between the archival components and the artwork within the exhibition, art and the archives it produces (or the archives that produce the artwork) are always inextricably linked. To reframe the question in relation to context, does all of the content of the exhibition become artwork— albeit archive-based—by virtue of being shown in an art museum or gallery? There is a tension generated by the idea that an artwork's value—in terms of people, places, and even money—changes when it leaves the site of its production and enactment, and is brought into the gallery. Are the work's participants relegated to artistic material, or does a gallery setting elevate the status for all involved? Is its status as art retained beyond the gallery?

The answers to these questions are subjective and will depend on whom you ask. Ultimately, it is the after-effects, or legacies, of Helguera's and Lacy and Riaño-Alcalá's projects that reflect their value in the world as art or otherwise. Both projects clearly resonate with those who experienced

45

them directly, as well as others who learned about them after the fact. In 2011, when the Medellín Biennial MDE11 invited Lacy and Riaño-Alcalá to show *Skin of Memory Revisited*, it became an opportunity to extend the project, reflecting on the decade that had passed since its initiation in 1999, and to understand where it had succeeded and failed. In the years that followed the first iteration of *Skin of Memory*, the Victims of Armed Conflict Care Program began laying the groundwork for Medellín's Museo Casa de la Memoria, which opened its doors to the public in 2012. Founded with support and input from many of the same collaborators involved in *Skin of Memory*, the Museum's mission is closely linked to the promotion of civil society and democratic engagement, with interactive educational installations that facilitate dialogue about Medellín's history of violence.

The effects of Helguera's *The School of Panamerican Unrest* are more difficult to trace, largely because of the project's vast geographic scope, with twenty-nine official participating communities (and other locales where he stopped). Taking Helguera's 2008 presentation of documentation of *The School of Panamerican Unrest* curated by Itzel Vargas at Casa del Lago in Mexico City, one of the project's art world echoes could be found in *panamericana*, an exhibition presented by kurimanzutto gallery in Mexico City in 2010 (although any connection between *The School of Panamerican Unrest* and *panamericana* was not acknowledged in promotional materials), which aimed to connect artists from different countries in Latin America. Published in 2013, Claire Fox's book *Making Art Panamerican* situates the visual arts programs of the Pan American Union within the context of hemispheric cultural relations during the Cold War. Helguera was extensively interviewed by Fox, whose work illuminates the institutional dynamics that helped shape aesthetic movements following World War II.

Another example of an outcome of Helguera's project was triggered by his stop in Mérida in the Yucatán, where he worked with La Escuela Superior de Artes. In writing about her experience with *The School of Panamerican Unrest*, then-director

Mónica Castillo witnessed the realization amongst students of how rarely art criticism was practiced. This prompted one student, Debora Carneval, to organize critiques of artwork made in Mérida. In its Panamerican address, the city of Mérida had declared, "there is a lack of critical analysis of the art scene; that we consider that the end is not to necessarily transgress, but rather to make art as we see fit in order to reflect our ideas."

A shared ethos of both Helguera's *The School of Panamerican Unrest* and Lacy and Riaño-Alcalá's *Skin of Memory* is that each was conceived to engage participants in ways that maintain their agency, whether by making declarations that reflect on local conditions, or selecting objects for display that represent collective loss. From the distance of time and place, it becomes clear that the relational nature of each artwork is supported by objects—maps, documents, newspapers, collages, videos, and souvenirs—whether it be in the production or presentation, as prompts for sustained engagement. As with any temporal form of art, the viewer must actively reflect upon the communication transmitted by the artwork, simultaneously expanding its meaning, recognizing the impossibility of a time-based, experiential artwork being singularly understood any one individual, in its entirety. This is the crux of exhibiting social practice: the art objects provide an aesthetic point of entry, but the installation is only fulfilled as socially engaged art when the dialogical prompt is activated relationally. The lesson learned might be a teachable moment in which objects are revealed to be essential, yet they never tell the whole story.

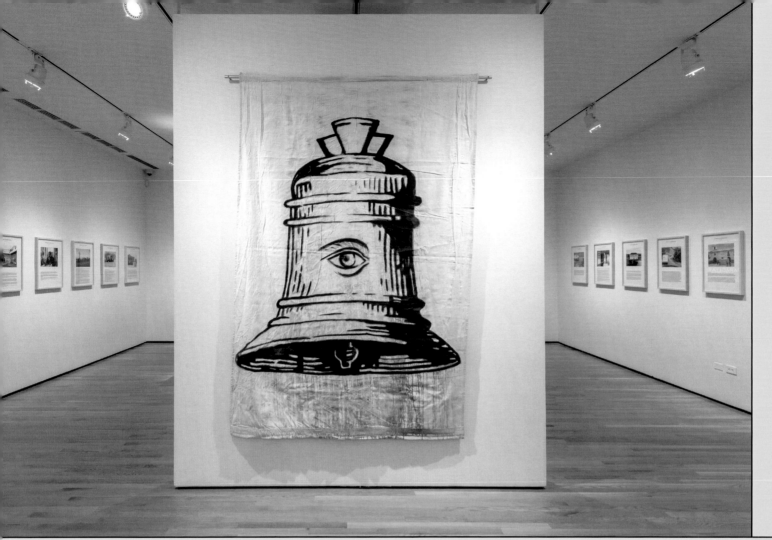

44 Suzanne Lacy and Pilar Riaño-Alcalá, *Skin of Memory*, 2018, installation view, The 8th Floor, New York.

47 Pablo Helguera, *School of Panamerican Unrest Banner,* 2006, installation view, AD&A Museum, UC Santa Barbara.

SKIN OF MEMORY
PROJECT DESCRIPTION
BY HOLLY GORE

Skin of Memory (1999–2017) is a social practice artwork by artist Suzanne Lacy and anthropologist Pilar Riaño-Alcalá that grew out of a community-led process in Medellín, Colombia. Lacy was invited by Riaño-Alcalá and a team of historians, political scientists, activists, and educators working to strengthen community in neighborhoods divided by violence. During the 1990s, Colombia was one of the most violent countries in the world. Drug cartels, leftist guerrillas, right-wing paramilitary groups, the Colombian army, and US interventions forged a multilayered conflict, subjecting Colombians to homicides, kidnappings, massacres, and forced displacements. In Medellín's Barrio Antioquia, rival youth gangs staked their territories and allegiances; to cross these lines was dangerous. *Skin of Memory* (1999) and *Skin of Memory Revisited* (2011) investigated spaces in which citizens could share histories and unite in mourning to rebuild their communities.

For *Skin of Memory* (1999) women and youth acted as collectors; they went door-to-door throughout Barrio Antioquia, gathering objects with powerful connections to the residents' lives and experiences and recording the stories that made them significant. Because the neighborhood was deeply territorialized, they created a movable museum, which displayed these keepsakes in a bus retrofitted with aluminum shelves. Over the course of ten days this museum of Barrio Antioquia was visited by 4,000 people, who were invited to write a letter to an unknown resident of the barrio, expressing a wish for a peaceful future. *Skin of Memory Revisited* (2011) created for the Medellín Biennale, reconvened participants to reflect on personal, social, and political changes in Colombia over the intervening decade between the first and second parts of the project. Lacy, Riaño-Alcalá, and their original collaborators organized an installation and public conversation at the Museo de Antioquia, an established city museum. In a dimly lit gallery, new and former objects of memory were exhibited on a long aluminum shelf lit with small white lights, reminiscent of the interior of the bus. Two video projections illuminated opposing walls, one of which documented the 1999 project, while the other showed former participants now reflecting on the past and future of civil society in Colombia.

For the exhibition and representation of the project in this book, *Skin of Memory* (2017) continues a dialogue with ongoing political processes and aligns with a significant moment in Colombia: the signing of a Peace Agreement with the former guerrillas of the Armed Revolutionary Forces of Colombia (FARC). The related exhibition and book pose a significant challenge for Lacy and Riaño-Alcalá: to consider how this new presentation in the United States will impact viewers' understanding of the work. US stereotypes of Colombians are enhanced by a Trump-era narrative that disparages Latin Americans—one that ignores the impact of US policies on the daily lives of youth in Medellín, California, or wherever drug-related policies or military aide are enacted. The US-led "war on drugs" and the "war on terror" have directly affected Barrio Antioquia, which, in past decades, was the main producer of "drug mules." Over time the conflicts in Colombia have been particularly deadly for youth, such as those who began this project, and now for their children. With *Skin of Memory* (2017) Lacy and Riaño-Alcalá hope to encourage a deeper curiosity for, as well as conversation about, the relationship between Colombia and the United States and its impact on the lives and deaths of youth in each country.

. la paraguay

. la trinidad

la 25

. el Parque

del infierno

. el baliska

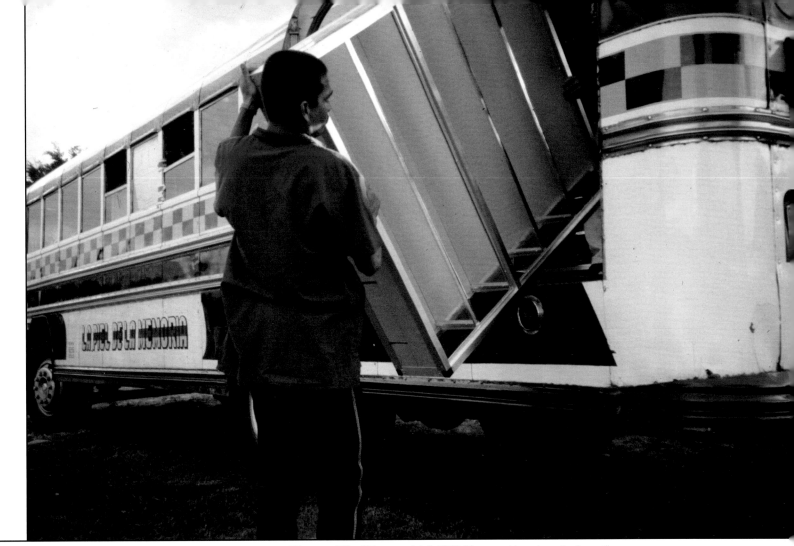

50 *Skin of Memory*, detail, 1999. Maps marking where the bus will appear.
 Photo by Suzanne Lacy.
51 *Skin of Memory*, 1999. Workmen installing. Photo by Suzanne Lacy.

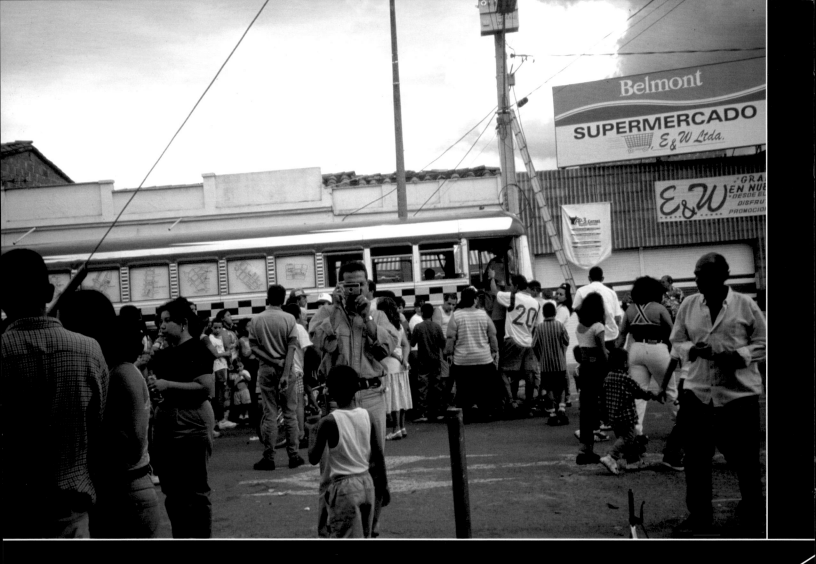

52 *Skin of Memory*, 1999. Barrio Antioquia residents lining up to see the bus.
Photo by Suzanne Lacy.
53 *Skin of Memory*, 1999. Maps mark where the bus will appear. Photo by Suzanne Lacy.

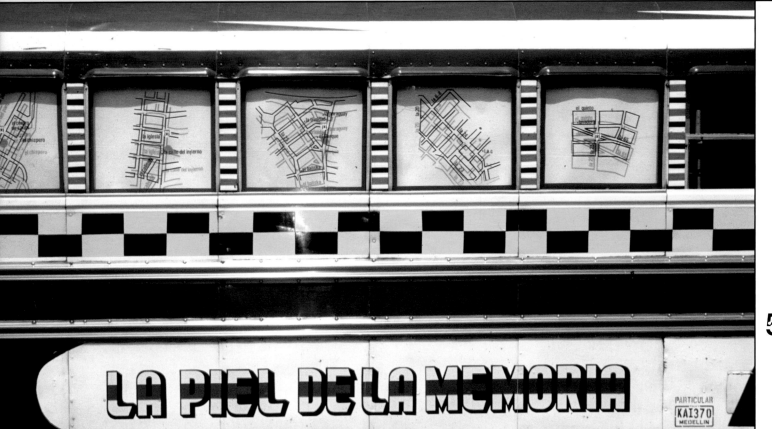

54

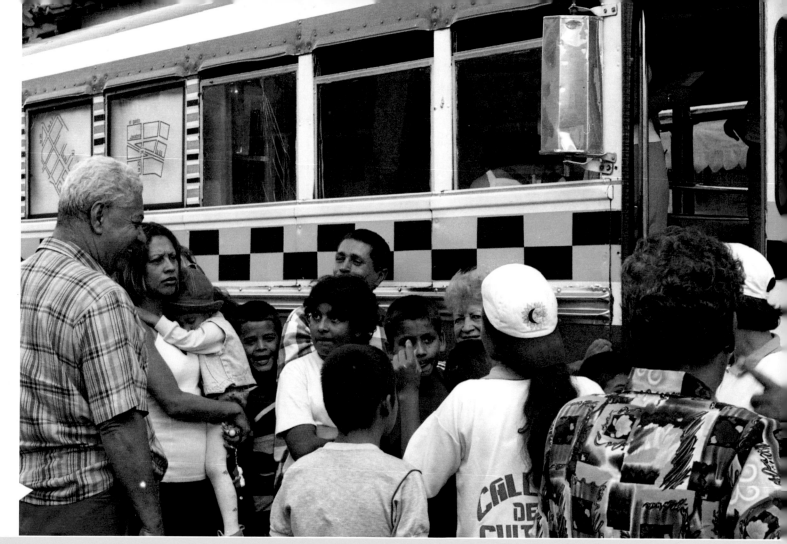

54 *Skin of Memory*, 1999. Visitors on bus leave letters to an unknown neighbor.
Photo by Pilar Riaño-Alcalá.

55 *Skin of Memory*, 1999. Visitors waiting to get onto the bus. Photo by Pilar Riaño-Alcalá.

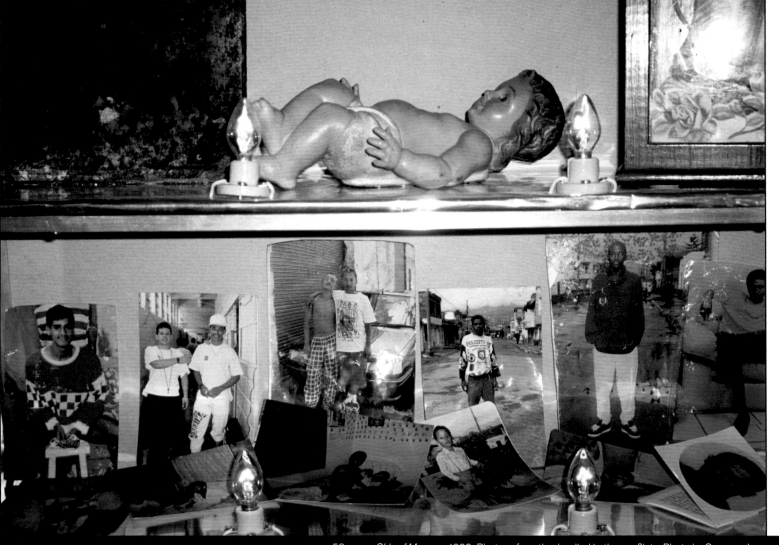

56 *Skin of Memory*, 1999. Photos of youth who died in the conflicts. Photo by Suzanne Lacy.
57 *Skin of Memory*, 1999. Visitors to the bus. Photo by Carlos Sanchez.

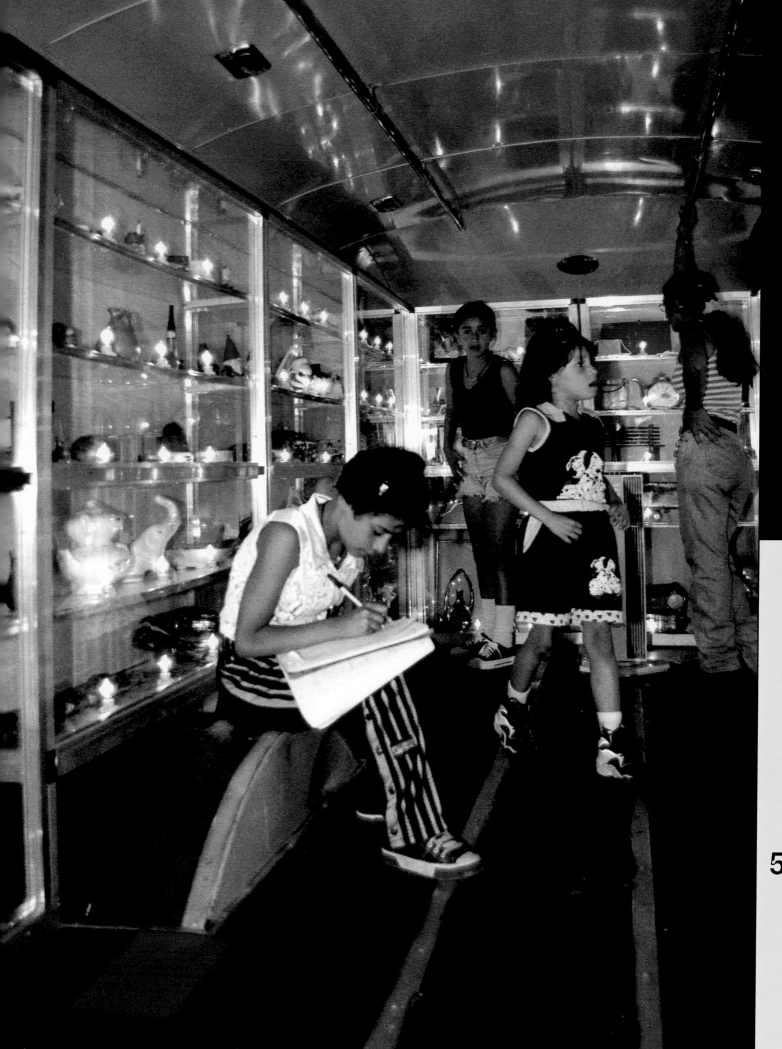

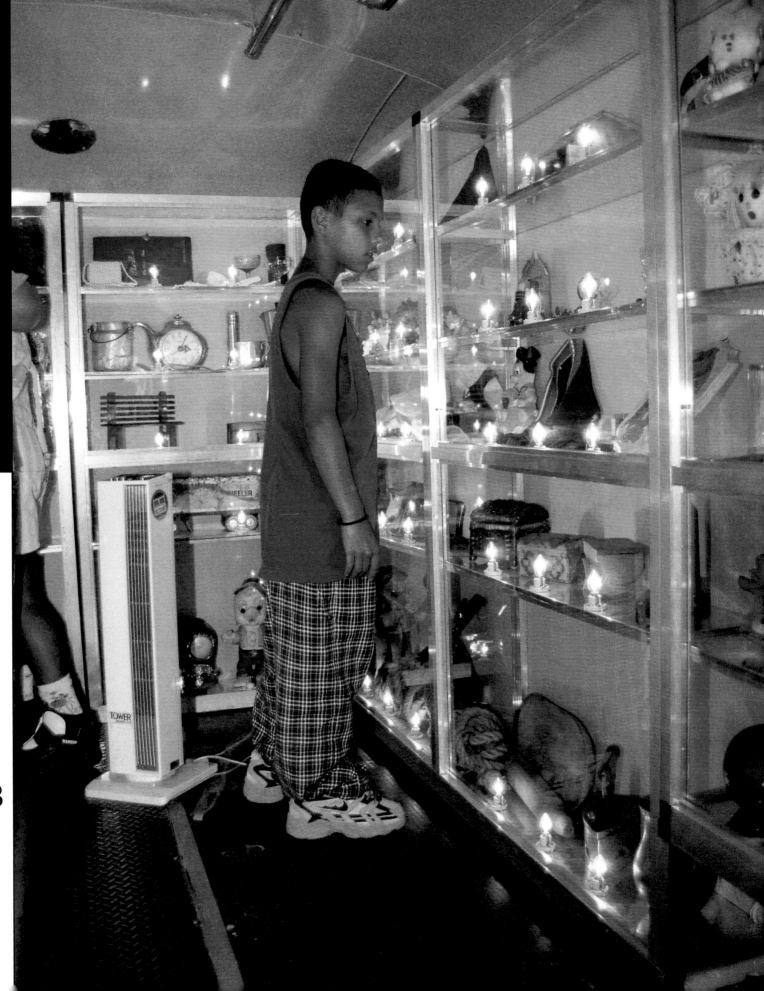

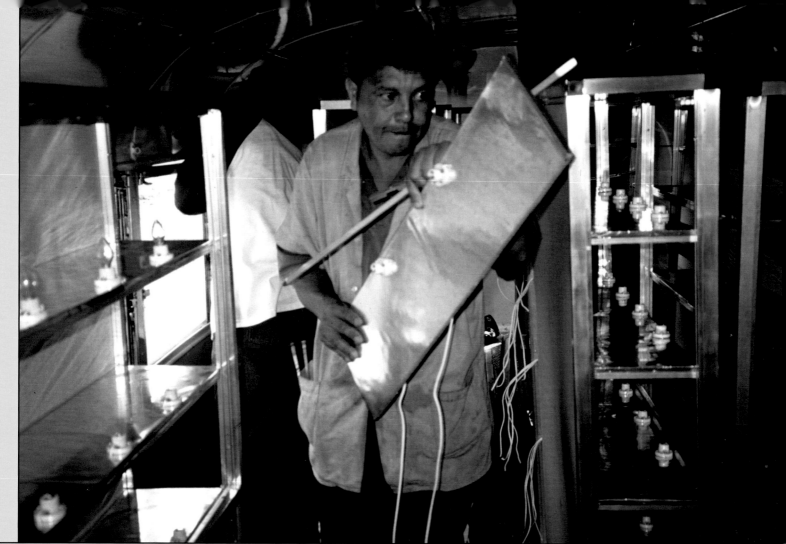

58 *Skin of Memory*, 1999. Visitors to the bus. Photo by Carlos Sanchez.
59 *Skin of Memory*, 1999. Workmen installing lights on the bus. Photo by Suzanne Lacy.
60–61 *Skin of Memory*, 1999. Closing performance organized by Pilar Riaño-Alcalá as bus moves to center of Medellín. Photo courtesy of Pilar Riaño-Alcalá.

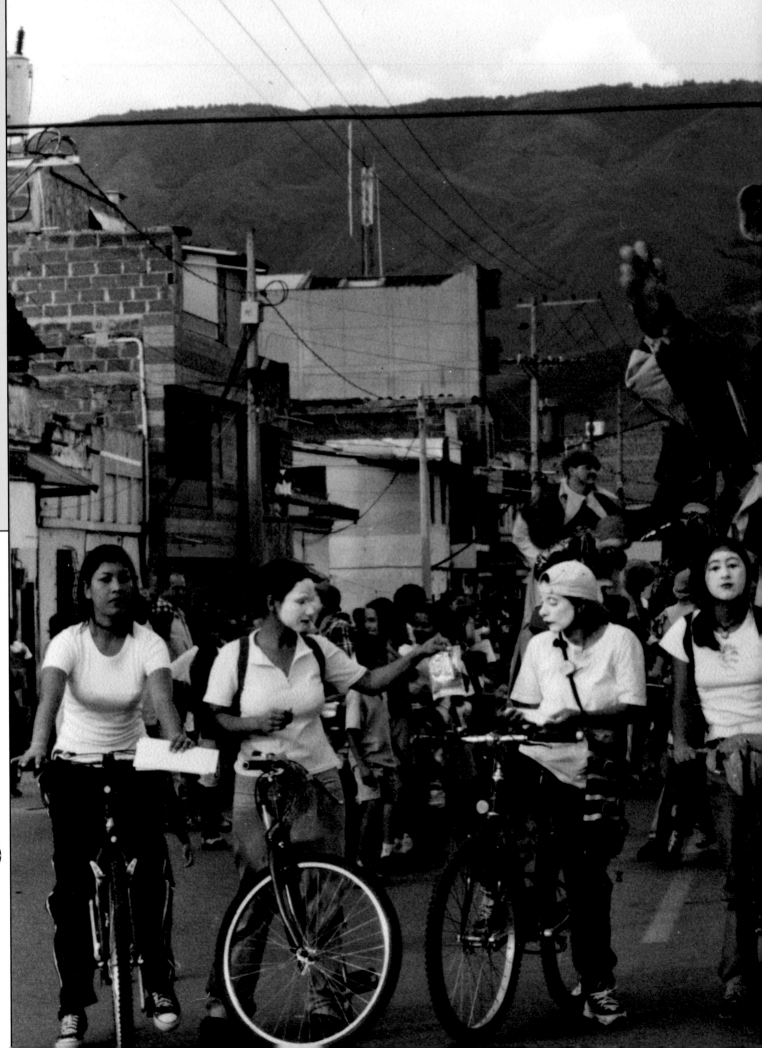

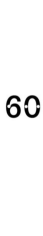

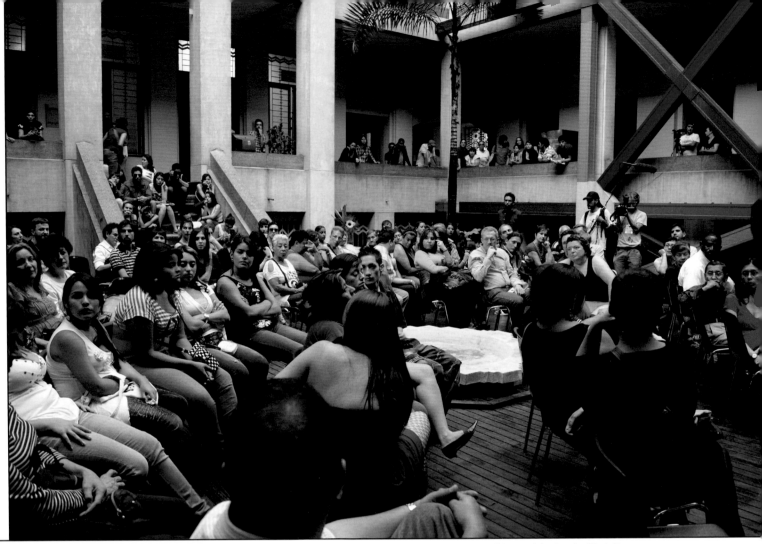

62 *Skin of Memory*, 2011. Installation view Museo di Antioquia, Medellín.
 Photo by Christina Sanchez.
63 *Skin of Memory*, 2011. Installation view Museo di Antioquia, Medellín.
 Photo by Christina Sanchez.

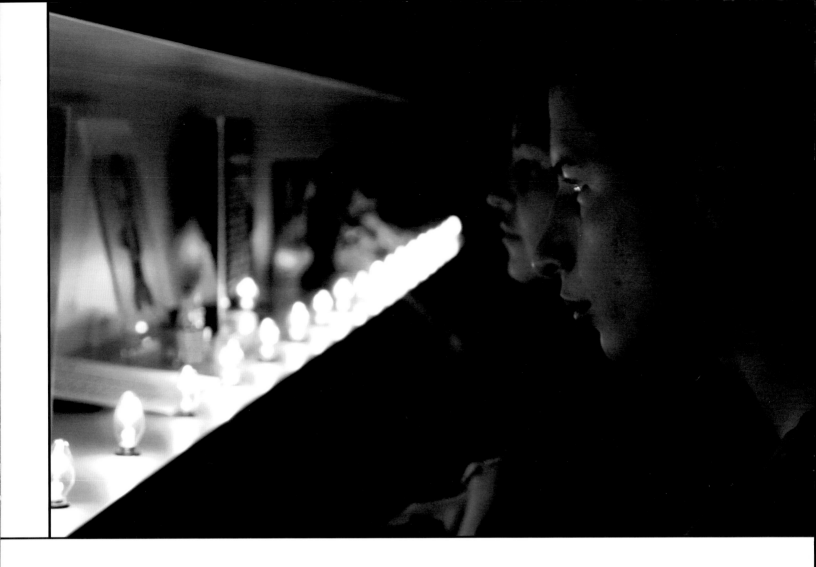

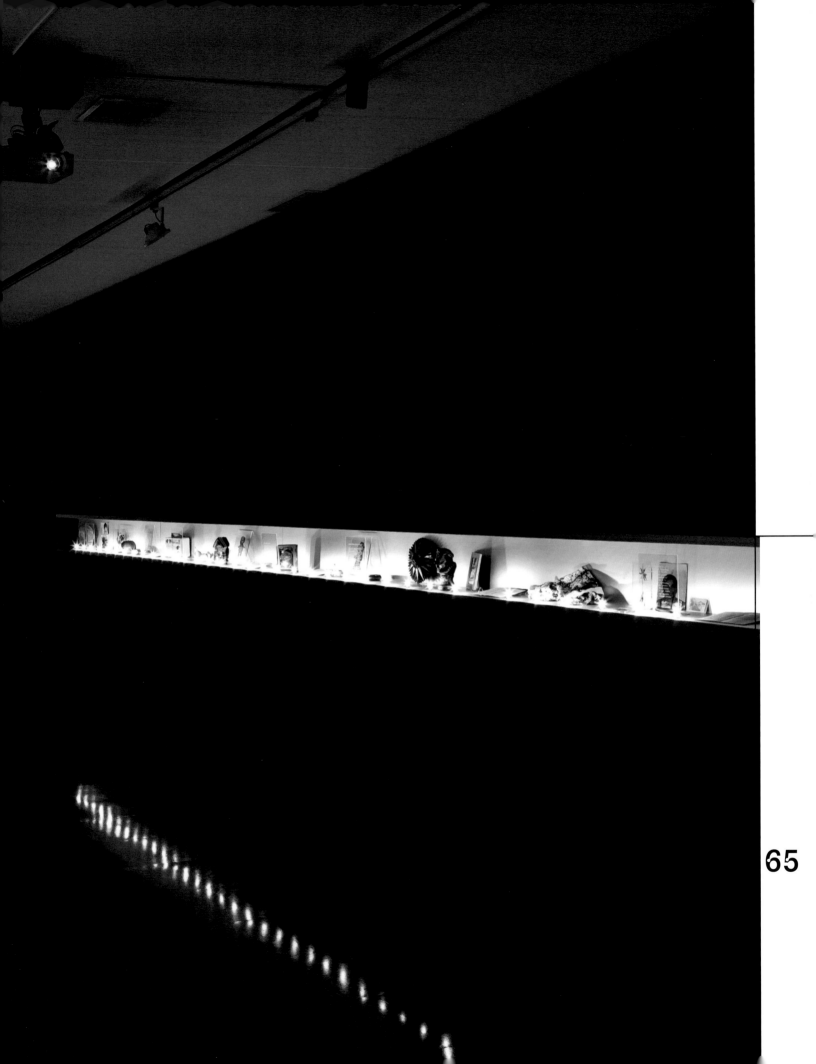

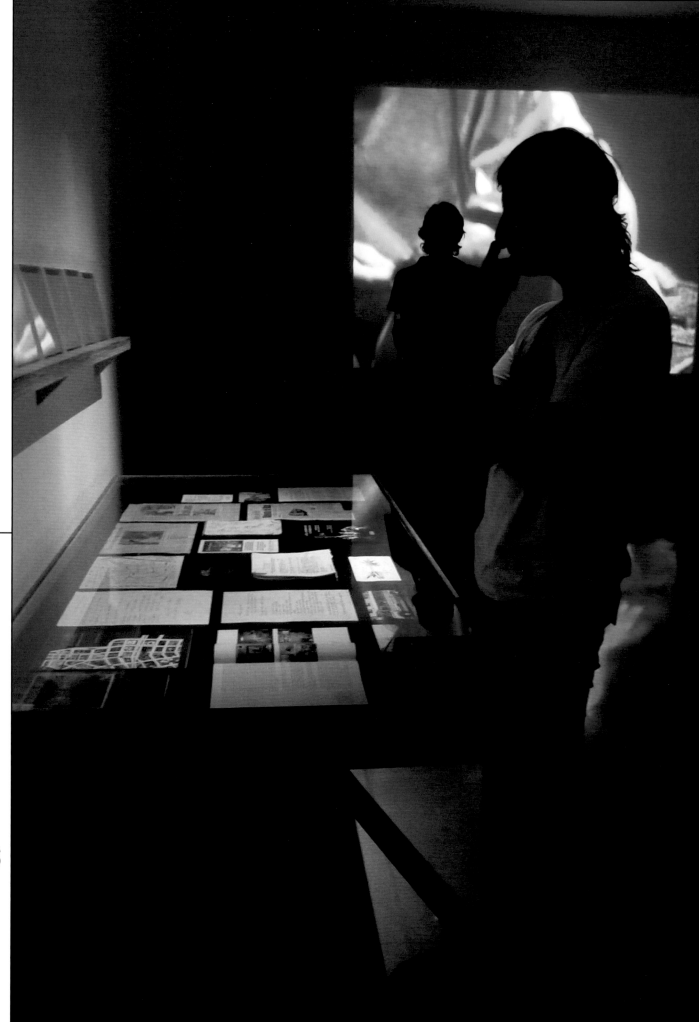

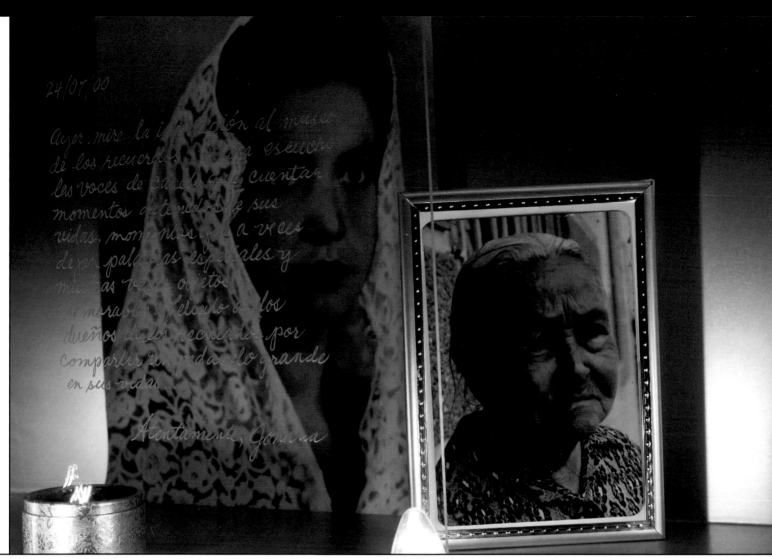

64–65 *Skin of Memory*, 2011. Installation view of 1999 videos. Photo courtesy of
Museo di Antioquia.

66 *Skin of Memory*, 2011. Installation view of archival materials. Photo by Suzanne Lacy.

67 *Skin of Memory*, 2011. Shelf detail. Photo courtesy of Museo di Antioquia.

RELATIONSHIPS, MATERIALITY, AND POLITICS IN THE SKIN OF MEMORY

A CONVERSATION BETWEEN SUZANNE LACY AND ANTHROPOLOGIST PILAR RIAÑO-ALCALÁ

SL One of the best things about this multiyear project has been our conversations. In 1999, one of our colleagues, William Álvarez, came up with the name "Skin of Memory" (La Piel del Memoria).

PRA *Skin of Memory* dealt with loss and its relationship to memory. With this title we connected the way memory relates to sensation, as does skin; we explored the reciprocal relationship between body and memory.

Memory, in this metaphor, has sensation—it is mutable. It is not only individual but also resides in physical spaces. If memory were like a texture, a surface, then wherever you touch that surface would be felt sensorially within the whole. We hoped that if we touched the skin of people's memories there would be some impact on their sensory world. The project's central image, a transformed school bus, became a collective body that stored a myriad of individual and family memories, as represented by the objects that they lent us. But you mentioned this idea of the skin as container?

SL Skin is the container of a living organism with its sinews, vessels, organs, chemistries, and fluids. When you peel back that skin, the body is exposed, vulnerable, revealed. Once this barrier between ourselves and our environment is removed, pain results. It was as if Barrio Antioquia was a living organism, with the skin as all that stood between the neighborhood and the tremendous loss experienced there. We explored that territory between the individual and the body of the whole of the barrio, with its calcified memories.

PRA A key to memory is that it is not only isolated within an individual. Much of what you remember is part of a relationship. When you work with people who have experienced violence for a long time, you see how memories of loss may become an obsession. Memories haunt them.

SL In Oakland, where I worked for a decade in the '90s, so many young people carry deep and largely unprocessed personal losses—the disappearance of fathers into prisons, the breakup of families, the deaths of friends by gun violence. Many have a huge reservoir of depression, fear, and anger that can lead to nihilism, recklessness, and despair about the future.

PRA Living with unprocessed loss and its consequent paralysis and violence is not restricted to poor youth. In Colombia, the president himself is trapped by memories of the kidnapping and murder of his father, and he swears to fight the guerrillas to the end.[2] Obsessive memory can take one to the point of revenge, and this might be expressed in many ways.

SL Through teaching women incest survivors I learned that making art is one way that people reconstruct memories of loss in order to gain some control over their experiences.

PRA I'm not talking about the act of remembering per se, but how, in the process of remembering, you remember as part of a group—the relational capacity of memory as a bridge between past, present, and future, between the individual and the collective, memory as a never-ending source of collective positioning.

SL You talked about the importance of reconciliation and neutrality in peace processes in Colombia. In Barrio Antioquia, did people who wouldn't normally transgress local factionalisms visit the bus in neighborhood areas that would not have been safe for them?

69

1 This conversation is a combination of texts from 2006 and 2017.
2 When this part of the interview was conducted in 2006, Alvaro Uribe was the president of Colombia.

PRA They went when it was in their own residential sector, except when it was in the central district, which everyone can access. Though they didn't necessarily physically cross territorial lines, as far as we know, we do know they began to make the kinds of connections that we were hoping they would make, a slight crack in the rigid boundaries caused by grief.

SL How do you know?

PRA Because of what they said when they left the bus, comments that are well documented. What we felt was important about art—that it lives as a visual and embodied memory—proved to be the case. The bus remains embedded in people's minds as a place of memory and a record of suffering, a lived sensory and collective memory.

SL In this third iteration of the project, now in 2017, we began with the question of whether this installation is a documentation of two previous manifestations or a new work? Are we reflecting on projects from 1999 and 2011? I am interested in how the work and our conversation continue.

PRA We are reflecting on the current implications of those past projects: what are the movements this project inspired in both social and political practices? Now we are working with three women in Medellín to collect objects for this show. We cannot actually keep them because their owners treasure them, but what makes those objects meaningful is that they are part of a very dense network of relationships between people and their pasts, and between you and me. They continue to speak to us in the present, and what we want to consider is the question: what do these relationships continue to tell us?

SL One of the most difficult things to portray in social practice art is experience including that in relation to others. In museum installations, social practice artists deploy a series of tropes. I worry that in a US context objects displayed on a shelf will be collapsed into a simple narrative: here is this object, owned by this family, representing this story of loss. In the bus, we made specific decisions not to reveal the narrative or the ownership of each object. But, in educating a US audience, we should carefully stage enough narrative context to create what amounts to a new position from which viewers can witness this Colombian reality.

PRA In the beginning of our conversations on the meanings and materiality of these objects, we explored how to avoid fetishizing or instrumentalizing them. We worked from the idea that violence and armed conflict objectify people, dehumanizing them as "an other," the enemy. We thought we could only challenge this dehumanizing impulse if we reconstructed the relationality between the people, the place they lived in, the territory where they walked, and the things and stories they kept to remember their loved ones.

SL When I first came to Medellín in 1999, at the invitation of you and your colleagues, it was a real privilege to enter the conversations there. That Alonso Salazar, a journalist and author on youth culture and violence in 1999, had become the mayor when we worked there in 2011, indicates the level of engagement that we all had in the civil society discourse. For me, entering a context where practices from anthropology, education, activism, and art weren't isolated within the academy offered a rare opportunity to be part of a politically effective team. One of the reasons I've stayed interested in

After more than five decades of armed conflict in Colombia, the government of Colombia and the Revolutionary Armed Forces of Colombia (FARC), a leftist guerrilla group, signed a peace agreement in December of 2016.

3

the project over time is that is has an ongoing embeddedness in the social and political life of Colombia.

PRA When we first began to think about the project, we felt that it might strengthen local peace processes that were being negotiated and broken repeatedly during those years. A peace process is as much about trust building and relationship building as it is about negotiating the content of the agreements. In the context of Colombia today, with the unprecedented signing of a peace agreement between the government and the Revolutionary Armed Forces of Colombia (FARC), this is more relevant than it was even then.[3] It also has international importance, because when I think about police violence and Black or Latino youth in the US today the same type of questions come to the fore.

SL Exactly. We began this work together based on my work in Oakland, your work in Medellín, and the cultural dynamics that were just coming into focus about the ways societies violated the racialized bodies of youth, both of us were interested in the connection between young people, the violence inflicted on them, and the politics of our two countries.

PRA Someone in Medellín put it this way: this is art that matters, not necessarily by leaving behind a monument, but by fostering relationships and deeply political conversations. *Skin of Memory* was not about an anthropologist doing art or an artist doing anthropological research. It was an interdisciplinary dialogue that included all types of knowledge exchange: the knowledge of our team members Ruben or Angela as social practitioners, of Alonso as a politician, of the youth from Barrio Antioquia who worked on the project—Sebastian, Nancy, Milton, or Elliot—who had everyday experiences of death, loss, and gang violence.

SL I remember during my first tour of the barrio I saw a roped-off street scene with a young person lying under a blanket, the victim of gang violence. It was not unlike what was happening in Oakland in the '90s. But while we were dealing with loss, we were also expressing the hope, pride, and optimism of local youth and adults by working together on this project. In the second project, the idea was to bring the work itself, and the people who produced it, into a place of cultural importance. Over a decade later, our installation conveyed the symbolism of the shelf, the objects, and the expressive meanings of a community's experiences.

PRA Today, we wonder what will happen when we bring this work to North America. What is the relationality that we are constructing here? Is there a meaningful connection for those who are immigrants, or the children of immigrants, with no legal status in the US, living in fear under the Trump administration? Is there a relationship with Black activists and youth who have experienced firsthand, similarly to youth in Medellín, that their lives don't matter from the perspective of the police and society at large?

SL The installation begins in a state university, so we should have a complex mix of visitors from the student body. But I wonder how many undocumented people or residents of poor communities will make their way to a gallery? An art museum is not necessarily the best way to reach larger audiences. As we work on this, we need to think more deeply about paradigms of social practice art, to move the field forward, to consider how audiences are also witnesses.

PRA With the work in 2011, we wanted to examine ideas of responsibility: What is the responsibility of those who are not part of the community that experiences everyday violence? What is your role when you enter the museum? That's when we began to explore witnessing as a practice of being accountable to each other, in new forms of relationality, between the witness and the storyteller, the witness and those who provide testimony, or the witness and the object.

SL While the first project's focus was Barrio Antioquia's individual and collective memories and how they spoke to youth violence and the city, in 2011, we focused on the relationships formed during the project in 1999, and the intervening time between 1999 and 2011 for both Barrio Antioquia and Medellín. The newly borrowed objects were, in a sense, the material link between those two moments in time. The reunion conversation—in the middle of an international conference, for over 75 people who participated in 1999—was a performance of self-enactment by that community. I really enjoyed that moment of reconnection.

PRA Why was it special for you?

SL Well, aesthetically I like the notion of "performing" life, bringing people back together to reflect on the intervening years in Medellín and what the project meant for them personally and politically. In another sense, it's fairly simple: I loved seeing everybody again and knowing that I was part of a community engagement, a process, and that I remain in people's memory, as they remain in mine. I am committed to that time and those conversations from 1999 through 2011 and even up to today. It feels almost familial. But there's something in that kind of love that is both personal and political. It's love that is civic minded and has a commitment to ethical relationships, a motivation for social justice.

PRA Because there are so many debates about what makes something transformative and what social justice looks like, some of the most basic ideas risk being lost. As the Indigenous Lakota people say in greeting, "All our relations," to stress we are all related. This is the idea of relationships as the basis of life and how we experience politics day-to-day. The women we work with today, who were teenagers when we first met, have gone through so many things since 1999. So much has happened—pain and sorrow have been very present—but somehow this project captured and located them in a process that became transformative for them.

SL I agree, but am uncomfortable representing those transformations as a demonstration of the success of the projects. That is a default position for artists: four women's lives were impacted, and therefore the art was successful. It goes to your idea of emplaced witnessing.

PRA I see what you're getting at when you talk about artists. But this happened not only because of an art project, but also because it was something broader, with so many people and social movements thinking about how to respond to the crisis of youth dying as a result of armed violence. It was much more than a public art project. It was simultaneously an educational, political, and community-building exercise, a project of personal development and a project of local cultural expression. It was a project to find alternatives to violence and reconstruct civil society. Witnessing is central to this. It speaks

of accountability and responding to the call of those who provide testimony through their stories and the objects they lent us.

SL	The peace process is a significant marker of this moment, in which we produce a new iteration of our work. It's happening as we speak. Why are we doing this project now, and what are the dangers of doing it in the US?

PRA	One of the major challenges that Colombia faces today with the peace agreement is that many are not willing to trust the ex-FARC members or to accept them as full members of society.[4] This project taught us about the possibilities of listening to someone you may see as your enemy, to connect with them through another means, through the act of witnessing. So for me, it speaks to the peace process in quite significant ways.

SL	Now we're getting into the heart of the conversation. One of the first lessons that you taught me was, "don't come to Colombia thinking this is only about drug violence." When there, I was acutely aware, not so much of my whiteness but of my US-ness. You explained the multiple violences and displacements that created the Medellín context. You see this US stereotype of Colombia and drug cartels now in the Trump-era narrative: that it is Mexican gangs that cause violence in the US, not our drug usage and gun sales.

I think your reminder about the genesis of this project in racialized and politicized youth experience and its relationship to, for instance, the Black Lives Matter movement is important, but this connection has not yet materialized in our installation.

PRA	We do need to clarify it further. The Colombian peace process for those in the US and for the visual art world may appear as a distant experience, but it is not that remote when you consider governmental policies. The US-led war on drugs has had a direct effect on Colombia and particularly in Barrio Antioquia. In the 1950s through the '60s and '70s, most of the people who became drug mules carrying cocaine and marijuana to the US were from Barrio Antioquia. During the last decade, US funding of Plan Colombia—the largest military aid package to a Latin American country—has failed in ways that directly impact people there.

In terms of international politics, we need to think on how the US relates to Latin America through policies and aid and the impact of this relationship on the daily lives of the youth in Colombia, but also the youth in Oakland or Canada, or the people impacted by these drug-related policies. We are connected in one way or another.

SL	We should see this installation in Santa Barbara as the beginning of an inquiry on context. We're struggling to produce physical forms in the gallery that communicate the complex reality we lived through the projects. How this work might now operate within the context of Colombian peace efforts is also compelling.

PRA	Your work has taught me that this type of conversation doesn't take place as much in the installation as in the moments of encounter and dialogue that the installation fosters. This happened with the first project when people came to the bus and talked about memory and loss, and it happened again in the museum in 2011 during our reunion conversation. I wonder how this installation may trigger conversations here with the university students, or beyond? They need to feel invited to create a relationship with the exhibition.

73

FARC has been involved in the continuing Colombian armed conflict since 1964.

PEDAGOGICAL
PUBLICS
BY SHANNON JACKSON

The arguments of this essay are in dialogue with these texts: Nicolas Bourriaud, *Relational Aesthetics*; Grant Kester, *Conversation Pieces* and *The One and the Many*; Shannon Jackson, *Social Works*; Johanna Burton, Shannon Jackson, and Dominic Willsdon, eds., *Public Servants*; Nato Thompson, ed., *Living as Form*; Claire Bishop, *Artificial Hells*; Ted Purves, *What We Want Is Free*; Tom Finkelpearl, *What We Made*; John Dewey, *Art as Experience*; Paulo Freire, *Pedagogy of the Oppressed*; Suzanne Lacy, *Mapping the Terrain*; Pablo Helguera, *Education for Socially Engaged Art*.

1

Lacy and Helguera: we have a great deal to learn from this artistic pairing, indeed, a great deal to learn about how "learning" itself propels artistic making. Of course, Suzanne Lacy and Pablo Helguera have been implicitly paired—and compared—before. They have shared the dais in public dialogues and shared space in art catalogues and other publications. They have been found together on syllabi (including mine at UC Berkeley) and in many other books, events, workshops, and venues that seek to come to terms with the practice of socially engaged art. With *Mobilizing Pedagogy*, however, we have the chance to look deeply into the practices and processes of two artists and two art projects. In particular, we have the chance to see how these extraordinary practitioners claim and resist their identities as artists in order to create meaningful social experiences that are educational (though not in the usual sense), cross borders (often through unorthodox means), and move within the geography of the Americas, including the LA/LA geography signified and debated in 2017/2018 at Pacific Standard Time. In what follows, I follow a daisy chain through this proposition. So let me begin, again.

ART AND SOCIAL PRACTICE

As noted in the book's introduction, Suzanne Lacy and Pablo Helguera are exemplary figures in a socially oriented movement of cultural practitioners whose work challenges traditional parameters of art. In the wider world of art and culture, there are many different ways of labeling this kind of practice —relational aesthetics, social practice, post-studio art, community art, participatory art, and socially engaged art. Lacy herself coined the term "new genre public art" to characterize a mode of public art practice that differed from the nationalist traditions and plop-art conventions of public art, asking what might happen if art became truly "publicized," that is, undone and redone by the public's claims. If one creative model finds the artist working hermetically in her studio, releasing a finished work into a gallery or onto a public, other models now start with the site of arrival. New genre public artists and socially engaged artists are now trained to excavate the material, historical, and sociological

say that the aesthetic encounter is always a social encounter. It provides a space for large and small groups to gather; *pace* Modernist critics, the meaning and experience of the artwork will be influenced by the social context in which it is housed. To some degree then, social practice foregrounds a relational dimension in art that was always there. On the other hand, the techniques and skill sets of social practice art expand beyond the technical skills of brushwork or the manipulation of clay, so the expressive and conceptual skills of such work change when the art's site, its public dialogue, and its community engagement become central goals rather than peripheral effects.

At this point, it is worth noticing another shared dimension of Lacy and Helguera's work: their excavation of pedagogical practice as an art form and as a pragmatic resource for artistic action. Indeed, the social turn in art very much coincides with a pedagogical turn, even as many educational domains have come to rely on art to animate the classroom. Following in the educational tradition of John Dewey's *Art as Experience,* innovative pedagogical critics and teachers consistently turn to the arts—employing storytelling, image-making, peer-to-peer dialogue, and hands-on exercises to inspire active learning. Of course, these artistic techniques in education can be adapted to reinspire the experience of cutting-edge public art as well. As such, we also find many social practice artists using these aesthetically inspired pedagogical techniques in their own community engagement. Indeed, Helguera's own book, *Education for Socially Engaged Art*, is a pragmatic exploration of this synergy. The stories, images, and perspectives of participants do not simply respond to the artwork but are themselves part of the art's production. Interpretive and educational engagement does not only come after the artwork but is part of its origin.

For artists such as Lacy and Helguera, this pedagogical shift also has politics attached. It echoes Dewey's conceptions of the democratic potential of pragmatic pedagogy, as well as the perspectives of Paolo Freire on the power of radical pedagogy. As elaborated in Freire's *Pedagogy of the Oppressed*, socially responsive education requires a shift not only in content but also in method. Specifically, it must counter

hierarchical and unidirectional methods of what Freire called "banking" education into participatory pedagogy where power is shared among teacher and student. Such practices adapt themselves well to situations where artists and activists are also concerned with their own hierarchical positions vis-à-vis the communities they serve. New genre public art thus makes use of new genres of public pedagogy. Whether framing Panamerican exploration as a "school" or making transformational use of a "school bus," Helguera and Lacy's experiments demonstrate how a pedagogical consciousness can transform the art experience and conversely how schooling could be transformed by an aesthetic imagination. At a time when art seeks to become more pedagogical—and the school seeks to become more artful— such social practices embody a mutually productive intersection.

PUBLIC PEDAGOGY AND MOBILITY

"Share a meaningful object with others," said Lacy and Riaño-Alcalá, to shaken communities surrounding Medellín. "Write a new declaration for your city," said Helguera, to artistic communities across the longitude of a Panamerican circuit. In both cases, the artists extracted and circulated a cherished exercise of progressive pedagogy. Within *Skin of Memory*, Lacy and Riaño-Alcalá asked their participants to investigate their personal archives. Sometimes, this meant peeling back the layers of trauma and violence; sometimes this meant touching the treasured stories of lost family history. In all cases, this meant daring to retrieve a delicate object of deep personal value and daring further to share that object with others. It meant sharing that object with strangers unknown, strangers who might even have been connected to one's experience of trauma and violence. It was a volatile pedagogical exercise of show and tell. Some seven years later, Helguera's gathered communities marshaled and reimagined the rhetorical address of a democratic declaration, connecting anew to that first person plural— "WE, the PEOPLE"—and allowing themselves to deliberate about what that pronoun could possibly signify in complex political times. Both gestures opened the process of aesthetic

making to a community of participants that exceeded the authorial vision of the artist-teacher. And both gestures made use of progressive pedagogical techniques that value the stories and aspirations of citizens and students as more than, or as much as, those of politicians and teachers.

It seems no coincidence that these two artistic projects gained their energy and inspiration from a Latin American imagination —what for some might be called an "Americas" consciousness or, for others, a Bolivarian consciousness. The inspiration and compass for both those projects seem to ally with a southern hemispheric understanding of hemispheric connection. Their sensibilities recall the performative pedagogy of Paulo Freire and Augusto Boal as they plotted a new revolution—as well as that of the more recent, much-heralded Mayor Mockus of Bogotá, who understood the role of art in reimagining civic connection. The political-aesthetic leadership traditions of Latin America are propelled, too, by the historical legacies of José Vasconcelos and José Martí, as well as Simón Bolívar himself, in plotting a movement that truly *moved* across regions of the world. In both cases, *Skin of Memory* and *The School of Panamerican Unrest* "move" in a school bus and across geographies variously mobilized under a school's portable pop-up tent. They are guided by a "South" American tradition of progressive pedagogy that undoes the borders within and across the regions that they encounter. Borders among barrios are shaken loose when memories of lost children are shared. Borders between "South" and "North" America are undone by Panamerican people and Panamerican practices that unsettle South/North distinctions, opting instead to (s)pan into a networked conversation across the equator, across LA and... LA.

MOBILITY AND ART, AGAIN

Having routed through a daisy chain of connections—among social practice, pedagogy, and geography—we are ending where we began in the space of art. When Riaño-Alcalá reached out to Lacy after doing on-the-ground social work in Medellín, she knew that an artistic consciousness could help advance the community work she had already begun. An art project was allowed

a degree of mobility and freedom to travel across psychological and geographic lines that were otherwise taboo. Meanwhile, in order to activate a public conversation about the Americas, Helguera's mobile project relied upon artists as well; a network of artistically allied friends created landing points for *SPU's* unrest across a Panamerican line.

But artistic mobility is not only a spatial concept but also a temporal one. The *Skin of Memory* launched in 1999 and again in 2011; *The School of Panamerican Unrest* traveled in 2006, and its documentation has been recalled for various occasions since. Now in a joint exhibit, these projects are moving again; they are moving across time to enter 2017 and across medium, as the exhibition and this book attempt to recall processes of the past. Such a remounting inevitably invites new questions about the politics of mobility and global citizenship, especially at a time of debate about a fortified "wall" across the borders of the Americas. This recalling also creates new conceptual challenges and new aesthetic opportunities as curators install documentation of processes and social exchange inside the relatively static scene of an exhibition format. In such a space, mementos become spaces, and behaviors become artifacts. At the same time, these objects prompt a new kind of reflection as we stare into the glass-paneled reflections of past memories, or as we encounter a pop-up tent and imagine the conversations that might have happened there. And, in such moments, these specimens, images, objects, and artifacts might also become invitations to new processes and new behaviors. What memories must we recall now? What new conversations need to occur inside the gathering spaces of a school that will not rest? Recalling the social experiments of Helguera and Lacy also means imagining new public pedagogies for the future. Let's be sure that they—and we —keep moving.

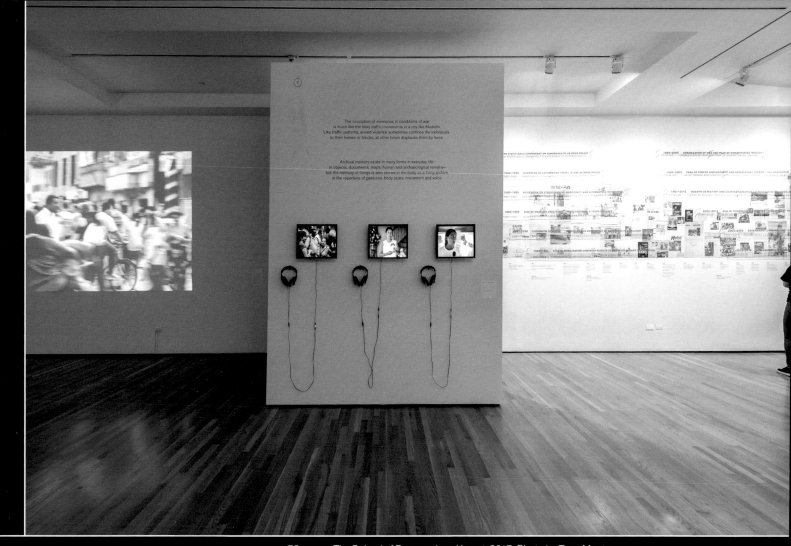

78 *The School of Panamerican Unrest,* 2017. Photo by Tony Mastres.
79 *Skin of Memory,* 2017. Photo by Tony Mastres.
80–81 *Skin of Memory,* 2017. Photo by Tony Mastres.

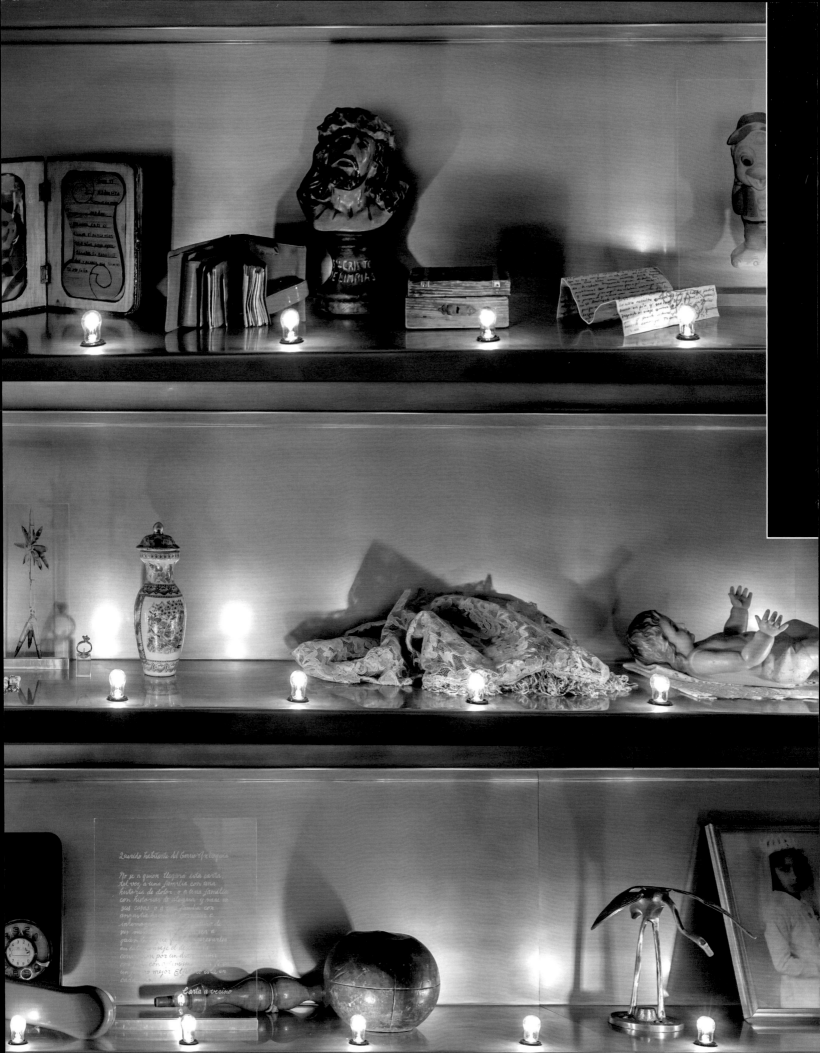

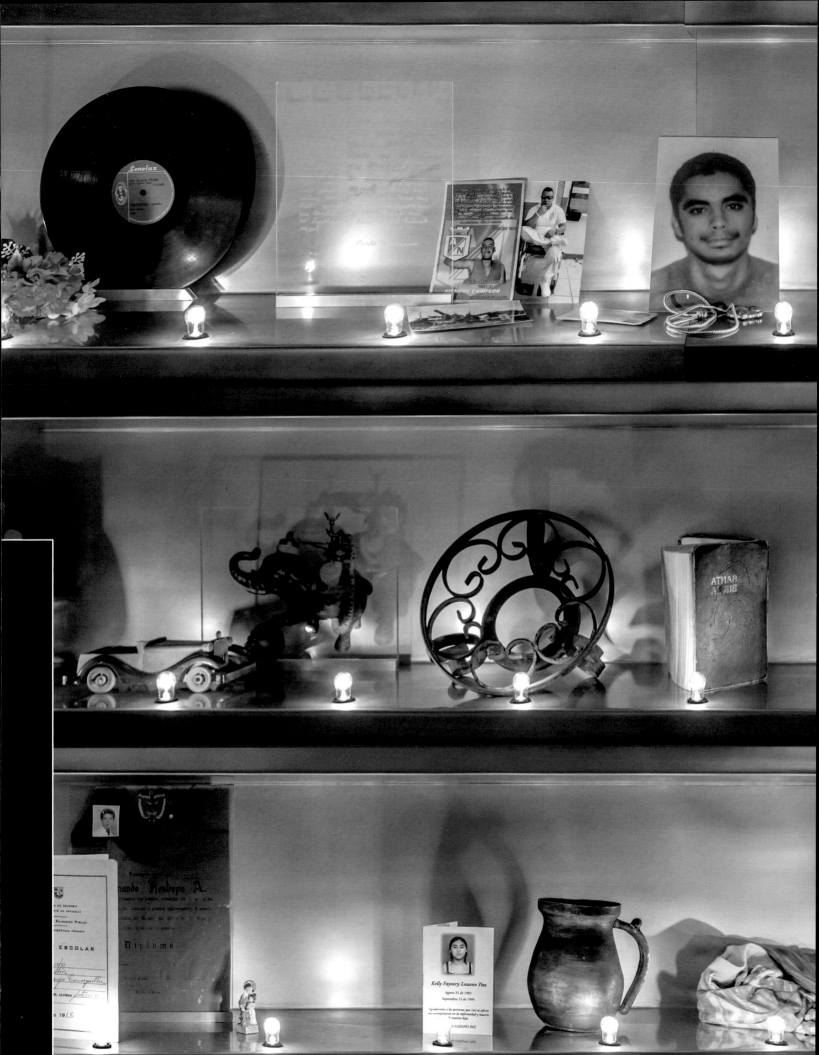

ON SOCIAL PRACTICE
A CONVERSATION
BETWEEN SUZANNE LACY
AND
PABLO HELGUERA

PH When we ask about what kind of expertise or practice we incorporate into our work, I see the artist as a composer: someone who does not play every single instrument but knows what those instruments can do, and how they can be incorporated successfully into a larger reflection. While we as artists have to perform many roles, the objective is not to impersonate or to supplant an actual expert but to create gestures that help bring other disciplines into the art discourse. Suzanne, how would you describe your methodology for approaching each of the constituencies in Medellín that were engaged in your projects there?

SL I think there are incredibly varied sets of practices that social practice artists draw upon, from community organizing to conflict resolution. As I tell my students, the ability to negotiate is a definer of success in this work.

 I was invited by Pilar Riaño-Alcalá and several NGOs to support their ongoing work on building a civil society in Medellín. Pilar's book, *Dwellers of Memory* (2006), discussed local applications of "memory work" in Barrio Antioquia where youth deaths were astronomically high. I was invited to join the team because of the work I'd done in the '90s with Oakland teenagers. It was an incredible opportunity be part of a larger process—one I didn't initiate. My colleagues in Medellín were exploring how "the city educates." Now, many years later, Antioquia Province is "The State That Educates."

PH When I made *The School of Panamerican Unrest*, I did not have any pre-established strategy. In fact, when I conceived it originally, it was not meant to be a road trip: I thought it would be a series of encounters in different cities around the Americas. A lot of the project unfolded in real time, and a lot of the circumstances would have been impossible to predict until they actually happened. I had to use everything that I knew, at that point, about performance and education.

 At times I was an educator, an activist, therapist, and journalist. I was the screen onto which people projected their frustrations, interests, or ideas. I had to contend with performing all of these different roles, while learning how to perform them successfully. I also learned the importance of improvisation, of thinking on your feet, as new circumstances arose and evolved.

 My role as artist was played in a rather predictable manner until I crossed into Guatemala. After that point, the question of whether this project was art or not became gradually less important. *SPU* was really about coming to address and engage with local issues. And to be a successful listener and activator of conversations and debates that mattered in those places at the time.

SL What's interesting is that you traced—with your body—a learning trajectory for social practice. When your project first came across my radar, I thought, "This guy is positioning himself as a performer, as well as a student and producer of others' learning experiences." You created an expanded classroom to transcontinentally explore political, pedagogic, and interpersonal experiences, and you put yourself through an educational process as an artist.

PH Thinking about the artist as outsider, specifically what kind of license do you have to enter into a cultural community that is not your own? I think this is a delicate question that has become very important right now. Today we are witnesses of the

"biennialist" syndrome—the tendency to parachute artists into random cities and countries to make an artwork about that place, often with little engagement with the local reality. We know that a lot of site-specific work can mean well but is often misguided. And yet, I think it is also important to recognize two things: that as artists we can never shed the condition of being outsiders, and that this condition can be a strength when we are honest about it—i.e., when we don't pretend to be insiders.

I always think of Paulo Freire's pedagogy—how he approached relationships with others, acknowledging very directly, with whichever group he was working with, that we are not the same people. We have different personal histories, different cultural backgrounds, education, and perhaps social status.

SL I think you're right, but I can nuance this a bit with my involvement as a white woman in racial conflicts and, in other countries, as a US citizen in places where our government has been destructive. One has to be agile to work cross-culturally in circumstances where strong politics are at play, whether it's a man working with women or a free person working with prison inmates. "Difference" operates differently within various moments and contexts. Working with Pilar, I'm always very conscious of how deeply the US is implicated in the politics and violence in Colombia.

It's the degree to which you can listen, learn, co-create, analyze, and make an empathic connection through the work that positions you as a student of others. In each project I begin as a learner. What I learned in Oakland, in the early '90s amidst the rise of neoliberalism, working with the racialization of youth as political signifiers brought me to Medellín, Colombia. For the "we" that typifies all my work—it is collectively produced—the mutual exploration in an expanded classroom results in a project.

PH Absolutely, that was the way I thought of the school, but I never imagined *The School of Panamerican Unrest* as advocating indoctrination of a particular view. It was more like a horizontal platform for collective learning.

SL That process we are describing is often missing in colleges. The only way you get to proficient in community organizing is if you're willing to put yourself in risky and powerless positions. Universities have a hard time producing risky experiences, but they *are* good at teaching representational skills suitable for museums and galleries. While there is a genuine interest in exploring context-based social issues within university art education, the real "rewards" of the art world are still linked to the market.

Today, communication with the art profession is largely through some form of exhibition. It wasn't true in the '70s, or maybe I should say it wasn't true in my experience coming out of CalArts and entering a developing performance art scene. Since I was in school, when we eagerly adopted Portapaks and photography, the technology of presentation has developed exponentially. Where we used to use high 8 film, you can now use 70mm cameras. Presentation is much more important, which can be a dilemma for an art practice that comes out of ephemeral ideas.

Considering that our exhibition has been framed by the curators as involving "mobility, pedagogy, and engagement," an idea of translation is critical: there is the art in communities, and then there

are those to whom it is communicated—whether directly to people in a community, over news media, or to art professionals. In this translation from a Medellín installation and performance project to the exhibition, so many questions arise. Pablo, I'm curious about the striking visual quality of your work and how you navigate between the beautiful presentation of the work and the public sphere where the work is constructed.

PH When teaching social practice, I have noticed that many students come to the field without an art background. They come from anthropology or psychology, etc., but they have no knowledge of art history, nor have they made art objects. For them, art historical references from Duchamp to anyone else are remote and unclear. They struggle with the visual manifestation of the things they do.

This made me value the type of traditional studio education I received, through which I learned the basics of painting, printmaking, photography, etc. It is this proximity to making things that can be helpful in creating sensorial experiences. In addition, because I have worked in museums for twenty-five years, I do think a lot about how things are presented to a public and how they might interact with them, sensorially and intellectually.

I am grateful for having been exposed to traditional ways of making and exhibiting art, because they offer a toolkit for shaping experience. I see education as part of that toolkit, of course, particularly in how one considers the type of audience that one may engage with and the ways in which an experience could be meaningful to that audience. Finally, I think of ways in which this sensorial or intellectual type of engagement might manage to slow down the viewer to make the experience more meaningful.

SL That goes to that issue of being adept at communicating ideas to different audiences. Art does provide something other than the visual, and, particularly in social practice, we engage with ideas of coherence, political analysis, and the "shape" of engagement. What I like about *The School of Panamerican Unrest* is not how beautiful the display will be, though I know it will be, but the coherency of the idea. How does the body of an artist move from one tip of a continent to the next, organizing, formulating conversation, gathering people around it... there's an aesthetic in the idea and in the action itself.

PH When I talk about enticing or engaging the public, I don't necessarily mean aesthetically. I think it can also be a utilitarian type of engagement, where you offer them something that is useful, that is interesting, and that can play a familiar function. With the *SPU* project I proposed types of interactions that were familiar. Participants would come to talks, workshops, and civic ceremonies, at which we'd read speeches. At times it took the form of the political ceremony: we would sing anthems and then read speeches. The workshops **85** were more literary, something that people connected with in a very basic manner.

SL Pilar and I are struggling to capture the Medellín projects for a US audience. The complexity of the interacting forces and themes of that project read very differently when displayed in Colombia. In the US, we often think of Colombia through the lens of narcotrafficking. Our project engaged with a political trajectory, anthropological research, community development, and a national process of memory recuperation and policy formation. How do we show the complexities of violence and

US interventions, the nuances of relationships that we formed and that still operate over time, and the way in which social scientists are deeply engaged with constructing a civil society, all of which has led to the current peace process?

I'd be curious, Pablo, what has the process of preparing this exhibition brought up for you, as an artist? Because that's part of the reason you and I were interested in this exhibition, to crystallize these projects in forms of display.

PH　　　One challenge that this project has always presented for me is precisely how to fit it into an exhibition. I almost gave up the idea that I could authentically transmit or communicate what this project was. I think it's an intractable problem because I cannot bring people to the places and times where and when this project happened. Perhaps I have a very idealistic idea of what it means to "recreate." I do completely relate to your comments about when you present it, when you go through the motions of recreating something you did twenty years ago: it feels more like theater.

Given this, I've concluded that you can only create approximations of the experience. In one of my attempts to address this, I created an anthology for *The School of Panamerican Unrest*, for which I invited people who were a part of it to give a firsthand account of what they saw. I was disciplined: I did not want to influence the views of the contributors. Some were critical of the project, and that was okay. Some of them saw the experience differently from me, and that was okay too. I imagine this is like the process of reconstructing a historical event. When you compile witness accounts, everybody's perspective differs. No single interpretation becomes the final 'version," but we all know that the truth lies somewhere amidst the summation of these different perspectives.

SL　　　Yes, I can't show everything about a multiyear project involving so many actors, but our representation of the political issues inherent in our project doesn't yet feel complete. There's a responsibility to communicate clearly here, one that might be a bit different from other circumstances. We are displaying actual objects that represent residents' memories of loss; if we then prominently posted photos of the owners talking about their memories including, for instance, trafficking, it would reinforce US audiences' simplistic perspectives. But if we present a timeline of the political forces over a thirty-year period like the US drug war policies, including the moments when our project deployed its strategies, then the objects will hopefully read differently.

The second area I am concerned with representing is the inherent relationalities that have occurred over almost twenty years. This set of relationalities has taken place within a time frame during which political and personal events have shaped the lives of people there. I don't know how to talk about the intimacy of the common cause that we have with each other, the seventy-five or eighty people and beyond, who came together as a result of a variety of efforts by NGOs, social scientists, activists, and educators, some of whom later entered government. This project was a symbolic manifestation of an existing national effort to recuperate memory as a political force in the life of the country. The experience of operating within that context was so powerful for me, and I feel the responsibility of communicating it, without playing into US prejudices.

PH I think everything has deficiencies, and the best I can do is to see them together: photographs, documents, witness accounts, and video. That is closest I can get to narrating what happened. I think we just need to accept that these are ephemeral things and difficult to frame in a clean or final narrative.

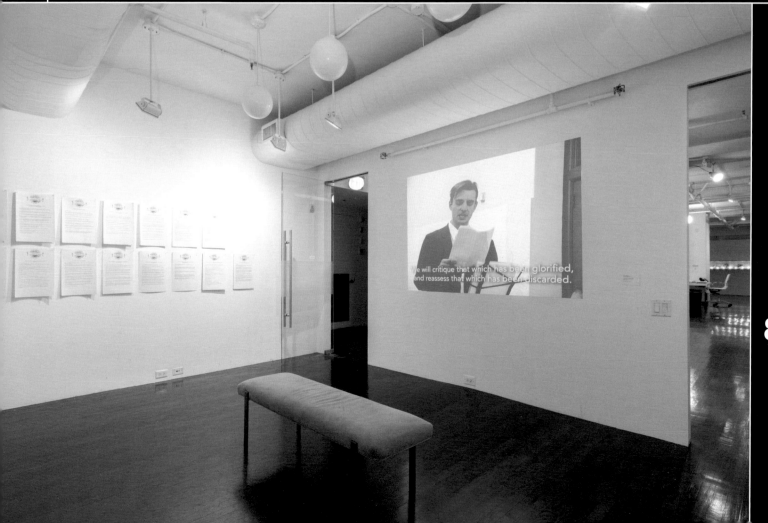

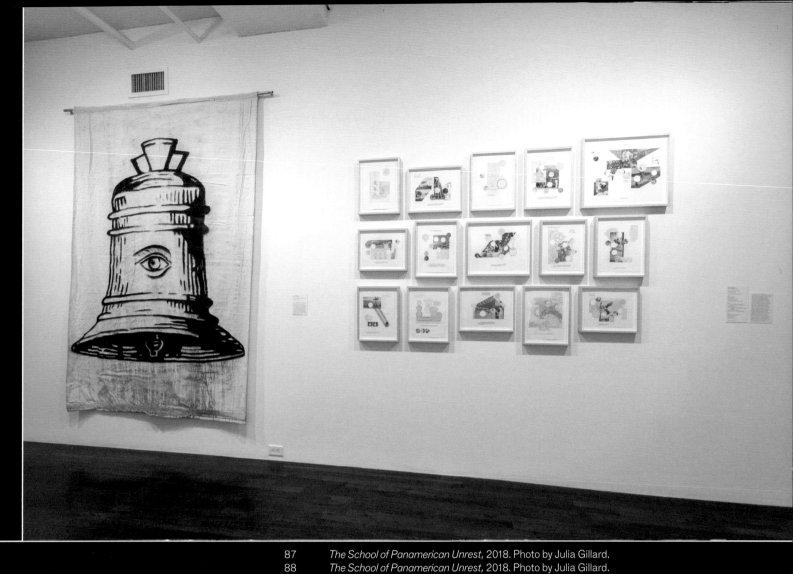

87 *The School of Panamerican Unrest,* 2018. Photo by Julia Gillard.
88 *The School of Panamerican Unrest,* 2018. Photo by Julia Gillard.
89 *The School of Panamerican Unrest,* 2018. Photo by Julia Gillard.

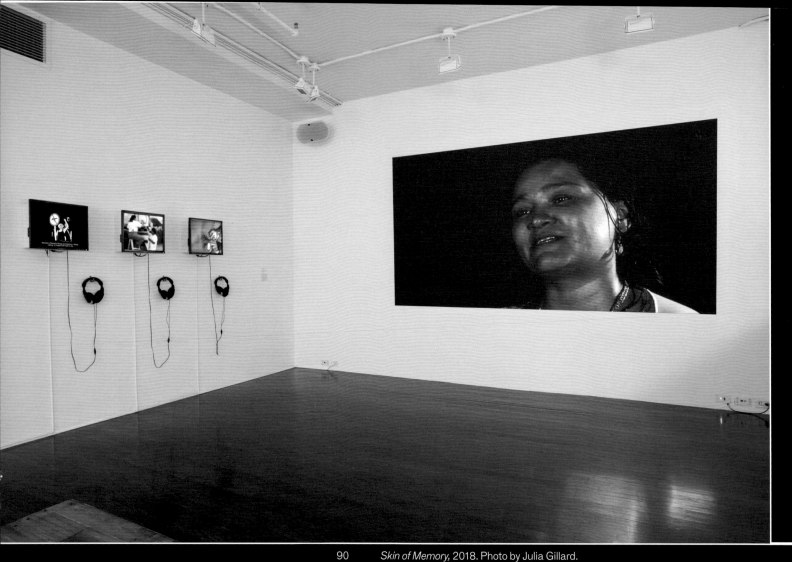

90 *Skin of Memory,* 2018. Photo by Julia Gillard.

PABLO HELGUERA (b. 1971 in Mexico City) is a multidisciplinary artist and educator based in New York City. Working in performance, photography, drawing, installation, lectures, and musical composition, among other diverse media, he creates artworks that investigate topics such as history, pedagogy, sociolinguistics, ethnography, memory, and the absurd. Helguera's projects often blur the line between pedagogy and politically engaged art, raising the question of how educational methodologies can contribute to social practice, and vice versa.

Throughout his career, Helguera has worked at the intersection of art and education. He attended the School of the Art Institute of Chicago, both an art school and a museum, where he worked in the museum education department while earning his BFA. He has since held positions in education at the Museum of Contemporary Art in Chicago and the Guggenheim Museum in New York, and is currently the Director of Adult and Academic Programs at the Museum of Modern Art in New York City. Helguera's tenure as a museum professional informs his art. Invested in social practice, he critiques cultural institutions while respecting their potential, with the aim of redirecting their power. Such an approach underlies *The School of Panamerican Unrest* (2003–2006), a community-oriented think tank, whose open-ended organizational structure invites audiences to consider what an educational institution can be.

Helguera has performed and exhibited extensively throughout Europe and the Americas. His works have been shown at the Museum of Modern Art, New York, Museo de Arte Reina Sofia, the Institute of Contemporary Art Boston, the Bronx Museum of the Arts, Brooklyn Museum, the Guggenheim, and many others. He is the recipient of awards from the Guggenheim Foundation, Rockefeller Foundation/Fideicomiso para la Cultura Mexico, Creative Capital, Franklin Furnace, and a Fellowship for Socially Engaged Art from A Blade of Grass. His publications include *The Pablo Helguera Manual of Contemporary Art Style* (2005), *What in the World: A Museum's Subjective Biography* (2010), *Education for Socially Engaged Art: A Materials and Techniques Handbook* (2011), *The School of Panamerican Unrest: An Anthology of Documents* (with Sarah Demeuse) (2011), and *Art Scenes: The Social Scripts of the Art World* (2012). In 2012, he received a PhD from Kingston University in London.

Over the past four decades, SUZANNE LACY (b. 1945 in Wasco, California) has created art that is grounded in themes of social justice. A pioneer of social practice, Lacy coined the term "new genre public art" to describe art that affects empowerment and change. In Europe, throughout North and South America, and in her home city of Los Angeles, Lacy has orchestrated projects that address difficult and complex issues such as rape, violence, labor, immigration, incarceration, aging, and gender identity.

After graduating from UC Santa Barbara with a major in Zoology in 1968, Lacy became a founding member of Judy Chicago's Feminist Art Program at Fresno State College. She moved with the Program when it relocated to CalArts, where she met Allan Kaprow, whom she credits with exposing her to the potential of participatory, performance-based artworks, or "Happenings." Lacy's best-known

early projects, *In Mourning and In Rage* (1977), a collaboration with Leslie Labowitz-Starus, and *Three Weeks in May* (1977), were feminist performances and media interventions. Staged on the city streets of Los Angeles, they transformed audiences into witnesses to the prevalence of rape in their midst. Community organizing, media representation, and social activism continue to define her artistic practice. *The Oakland Projects* (1991–2001) represented a ten-year involvement with teenagers in Oakland, California. The project resulted in a series of installations, performances, and political actions that gave a public voice to local youth on issues ranging from police relations to pregnancy. *Between the Door and the Street* (2013) brought hundreds of activist women together in conversations on New York City stoops.

Lacy's works have been exhibited at Tate Modern, the Los Angeles Museum of Contemporary Art, the Whitney Museum of American Art, the New Museum, and MoMA PS1, as well as the Bilbao Fine Arts Museum. She has received awards from the Guggenheim Foundation, Henry Moore Foundation, Rockefeller Foundation, and National Endowment for the Arts, as well as a Fellowship for Socially Engaged Art from A Blade of Grass. Also recognized for her academic work, she edited *Mapping the Terrain: New Genre Public Art* (1995) and authored *Leaving Art: Writings on Performance, Politics, and Publics, 1974–2007* (2010). Lacy was founding chair of the MFA program in Public Practice at Otis College of Art and Design in California. In 2013, she received a PhD from Gray's School of Art at Robert Gordon University in Aberdeen, Scotland, and is currently a professor at the Roski School of Art and Design at the University of Southern California.

ELYSE A. GONZALES is the Assistant Director/Curator of Exhibitions at the Art, Design & Architecture Museum at UC Santa Barbara. She has organized numerous collection exhibitions and group shows, including *Shana Lutker, Anna Sew Hoy, and Brenna Youngblood: CB08 the California Biennial* (2008), *The Stumbling Present: Ruins in Contemporary Art* (2012), *Peake/Picasso* (2013), and *Starting Here: A Selection of Distinguished Artists from UCSB* (2014). In 2009, she initiated an Artist-in-Residence exhibition program, through which she has commissioned numerous artists to create new works in the museum's galleries. Gonzales received an MA from Williams College and a BA from the University of New Mexico.

HOLLY GORE is a scholar of modern and contemporary art whose particular focus is on craft. A PhD candidate at UC Santa Barbara, she is currently writing a dissertation that investigates the emergence of modernist woodworking practices in postwar design, sculpture, and pedagogy in the US. From 2016–2017 she was the Graduate Curatorial Fellow at the AD&A Museum, UC Santa Barbara, where she curated *Body Matters: Contemporary Art from the Collection*.

SHANNON JACKSON is Associate Vice Chancellor of the Arts and Design and the Cyrus and Michelle Hadidi Professor at UC Berkeley. Jackson's research and teaching focuses on two broad, overlapping domains: collaborations across visual, performing, and media art forms; and the role of the arts in social institutions and political change, including *Social Works* (2011) on contemporary trends in socially

engaged art. Most recently, she co-edited "Time Zones: Cross-art Collaboration in a Global Landscape," a special issue of *Representations* (2016), and *Public Servants: Art and the Crisis of Public Good* (2016).

ADETTY PÉREZ DE MILES is an educator and scholar of art education and visual art studies. An assistant professor at the University of North Texas College of Visual Arts and Design, her teaching is centered on inquiry-based approaches to learning and socially responsible teaching. She earned a dual PhD in art education and women's studies at Pennsylvania State University. Her dissertation, *Dialogic Encounters: The School of Panamerican Unrest*, investigates the pedagogical function of contemporary art. Pérez de Miles is the author of numerous scholarly articles on dialogic pedagogy, contemporary art, and feminist epistemology, featured in journals such as *Studies in Art Education*, *Knowledge Cultures*, and *Visual Culture and Gender*.

SARA REISMAN is the Executive and Artistic Director of the Shelley & Donald Rubin Foundation, where she oversees philanthropy in support of New York City-based organizations that connect art and social justice. As Artistic Director, Reisman has curated exhibitions including *When Artists Speak Truth* (2015), *In the Power of Your Care* (2016), and *The Intersectional Self* (2017) at The 8th Floor, on themes related to the Foundation's mission. Reisman was previously the Director of New York City's Percent for Art Program, overseeing a hundred permanent public art commissions for civic sites across the City. She earned her BA from the University of Chicago and participated in the Whitney Independent Study Program.

PILAR RIAÑO-ALCALÁ is an anthropologist and professor at the University of British Columbia. Her scholarship is primarily concerned with three broad themes: the lived experience of violence and displacement, the politics of memory, and the ethnography of social repair. Riaño-Alcalá has published widely on topics, including forced migration, historical memory, witnessing, and public art as civic pedagogy. From 2008 to 2013 she was one of the researchers of the *Grupo de Memoria Histórica* (Historical Memory Commission) in Colombia and is now an advisor to the National Museum of Historical Memory of Colombia.

As curators of the exhibition and editors of this book, we are indebted to artists Pablo Helguera and Suzanne Lacy, as well as Lacy's collaborator, cultural anthropologist Pilar Riaño-Alcalá, for their significant contributions to the field of socially engaged art and their commitment to the process of developing this exhibition and publication.

The support we received from the individuals and institutions listed below helped us realize the exhibition, publication, and programming. For their generosity, friendship, and ongoing arts advocacy we thank Marcia and John Mike Cohen, Eva and Yoel Haller, the Shelley & Donald Rubin Foundation, the Interdisciplinary Humanities Center, the Western Humanities Alliance, and the UC Santa Barbara Department of Art.

We would also like to thank Neil Sherman of Industrial Metal Supply for his in-kind support of the fabrication of the shelf that is part of *Skin of Memory*, and the Bronx Museum of the Arts for their generous loan of Helguera's *Panamerican Diary*.

We are additionally grateful for the support of our colleagues and leadership at our respective institutions, including Bruce Robertson, Director of the Art, Design & Architecture (AD&A) Museum at UC Santa Barbara, and Shelley and Donald Rubin and James McCarthy at the Rubin Family Office. Both the exhibition and publication would not have been possible if not for the assistance of our devoted teams, who worked tirelessly to realize this endeavor. From the AD&A Museum, we would like to thank Todd Anderson, Winston Braun, Mehmet Dogu, Elizabeth Fair, Michelle Faust, Lety Garcia, Holly Gore, Rebecca Harlow, and Susan Lucke. From the Shelley & Donald Rubin Foundation and The 8th Floor, we thank George Bolster, Matt Johnson, and Anjuli Nanda. We are also grateful for the assistance of Lucia Fabio and Geneva Skeen from Suzanne Lacy's studio, Dressler Parsons from Pablo Helguera's studio, as well as Amy McFarland for her graphic design contributions.

We extend our thanks to UC Santa Barbara for their facilitation of the exhibition at the AD&A Museum, particularly Susan Derwin, Venessa Hornemann, Richard Ross, Jenni Sorkin, and Cristina Venegas. Additionally, we extend our gratitude to the leaders of many Santa Barbara cultural institutions for their support, notably Sarah Cunningham of the Atkinson Gallery at Santa Barbara City College; Patsy Hicks and Julie Joyce of the Santa Barbara Museum of Art; Maiza Hixson and Alan Macy of the Santa Barbara Center for Art, Science & Technology; and Pilar Tompkins-Rivas of the Vincent Price Art Museum.

ACKNOLEDGEMENTS

Mobilizing Pedagogy: Two Projects in the Americas by Pablo Helguera and Suzanne Lacy with Pilar Riaño-Alcalá serves as documentation of the exhibition, *The Schoolhouse and the Bus: Mobility, Pedagogy, and Engagement*. This exhibition and publication have been collaboratively conceived and organized by the AD&A Museum, UC Santa Barbara and The 8th Floor, Shelley & Donald Rubin Foundation.

Art, Design & Architecture Museum, UC Santa Barbara
September 27–December 8, 2017
www.museum.ucsb.edu

The 8th Floor, Shelley & Donald Rubin Foundation
February 9–May 12, 2018
www.the8thfloor.org
www.sdrubin.org

The Schoolhouse and the Bus was part of *Pacific Standard Time: LA/LA*, a far-reaching and ambitious exploration of Latin American and Latino art in dialogue with Los Angeles, which took place from September 2017 through January 2018 at more than seventy cultural institutions across Southern California. Pacific Standard Time is an initiative of the Getty.

Suzanne Lacy and Pilar Riaño-Alcalá would like to especially thank the following individuals who helped make *Skin of Memory* possible in the past and in this presentation.

PROJECT COORDINATION
Los Angeles: Lucia Fabio, Geneva Skeen
Medellín: Luz Adriana Arcila Jaramillo, Andrea Jiménez Escobar, Sandra Isabel Zapata Loaiza

DESIGN/PRODUCTION
Amy McFarland and Ironwood

VIDEO
Los Angeles: Peter Kirby, Media Art Services; Hannah Kirby; Christina Sanchez, Dean Brown (translation)
Medellín: Corporación Platohedro; Jorge Mario Betancourt; Dorothy Kidd, University of San Francisco; Jesus Abad Colorado, photographer

PROJECT SUPPORT
Industrial Metal Supply; University of Southern California; City of Santa Monica Cultural Affairs Division; Museo de Antioquia, Programa de Víctimas Alcaldía de Medellín, Corporación Región

SPECIAL THANKS TO Todd Anderson, Mehmet Dogu, Michelle Faust, Ruben Fernández, Lety Garcia, Jorge García, Rebecca Harlow, Montoya, Susan Lucke, Hernando Muñoz, Conrado Uribe, Sebastian Vargas Montoya, Angela Velásquez, and Juan Fernando Vélez

In Memory of Mauricio Hoyos, William Alvarez, and Kelly Lozano

95

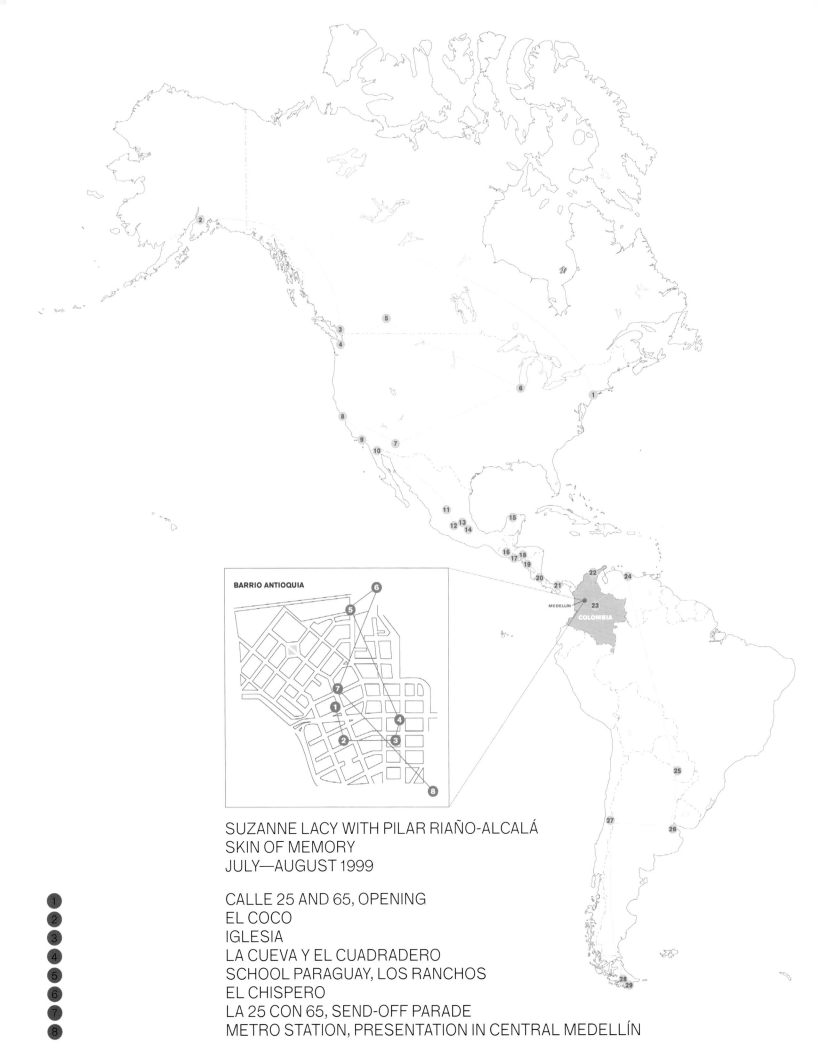

SUZANNE LACY WITH PILAR RIAÑO-ALCALÁ
SKIN OF MEMORY
JULY—AUGUST 1999

1 CALLE 25 AND 65, OPENING
2 EL COCO
3 IGLESIA
4 LA CUEVA Y EL CUADRADERO
5 SCHOOL PARAGUAY, LOS RANCHOS
6 EL CHISPERO
7 LA 25 CON 65, SEND-OFF PARADE
8 METRO STATION, PRESENTATION IN CENTRAL MEDELLÍN

MOBILIZING

PABLO HELGUERA
THE SCHOOL OF PANAMERICAN UNREST
MAY—SEPTEMBER 2006

1 NEW YORK, NEW YORK
2 ANCHORAGE, ALASKA
3 VANCOUVER, BRITISH COLUMBIA, CANADA
4 PORTLAND, OREGON
5 CALGARY, ALBERTA, CANADA
6 CHICAGO, ILLINOIS
7 TEMPE, ARIZONA
8 SAN FRANCISCO, CALIFORNIA
9 LOS ANGELES, CALIFORNIA
10 MEXICALI, BAJA CALIFORNIA
11 LAGOS DE MORENO, JALISCO
12 TOLUCA, MEXICO
13 MEXICO DF, MEXICO
14 PUEBLA, MEXICO
15 MÉRIDA, MEXICO
16 CIUDAD GUATEMALA, GUATEMALA
17 SAN SALVADOR, EL SALVADOR
18 TEGUCIGALPA, HONDURAS
19 MANAGUA, NICARAGUA
20 SAN JOSÉ, COSTA RICA
21 PANAMÁ, PANAMÁ
22 CARTAGENA, COLOMBIA
23 BOGOTÁ, COLOMBIA
24 CARACAS, VENEZUELA
25 ASUNCIÒN, PARAGUAY
26 BUENOS AIRES, ARGENTINA
27 SANTIAGO, CHILE
28 USHUAIA, ARGENTINA
29 PUERTO WILLIAMS, CHILE

PEDAGOGY: